Watercolor Secrets For

PAINTING

Light

Published by Art Instructions Associates
2 Briarstone Road, Rockport, Massachusetts 01966

Parts of this book were previously published as
PAINTING WITH LIGHT by Betty Lou Schlemm, edited by Charles Movalli.

ISBN: 0-929552-11-3

99 98 97 96 4 3 2 1

Distributed to the book trade and art trade in the U.S. by
North Light Books, an imprint of F&W Publications
1507 Dana Avenue, Cincinnati, Ohio 45207
Telephone: (513) 531-2222, (800) 289-0963

Edited by Herb Rogoff
Design & Production by Bridges Design
Designer: Laura Herrmann
Index by Ann M. Fleury
Photography: William LaCroix
Additional Photography: Betty Lou Schlemm
Project Coordinated by Design Books International
5562 Golf Pointe Drive, Sarasota, FL 34243

Printed and Bound in Singapore

This book is dedicated to Margaret W. Williams, a wonderful friend and a fine painter in her own right. Without Peg, my classes would never have started; without my classes, this book would never have been written.

And to Claes Dohlman, MD, who for thirty years has kept these eyes of mine seeing. Without Dr. Dohlman, how could I have ever painted?

My heart is filled with gratitude to both of these individuals and also to my many friends and students — who became friends — that all love this wonderful world of art.

And my appreciation to the late Helen Van Wyk and Herb Rogoff, long time friends who made it possible for this revised edition to be published.

To painter, writer, teacher and friend, Charles Movalli, who edited the initial book, "Painting with Light."

To Robert Wade, Thelma Leighton and Roland Rivest, painters who believed in me.

To Steve Bridges, whose enthusiasm in art is felt by all.

And to the Rockport Art Association, the second home for all who share the painter's life.

Watercolor Secrets For

PAINTING
Light

by Betty Lou Schlemm

Art Instruction Associates, Rockport, Massachusetts
Distributed by North Light Books, Cincinnati, Ohio

Table of Contents

Introduction

Introduction

From the time that man first made his mark on the wall of his cave, the art of constructing paintings has been in transition. Over the centuries that have passed since that initial, memorable creation, many giants have come on the scene, each adding a distinctive touch to the application of paint to a surface.

Today's methods for manufacturing paint have improved remarkably and, we like to think, our paints are superior to the ones the Old Masters had available to them. There is no question about today's paint tubes, which are a far cry from the animal bladders that were used for paint storage right into the early 1800s.

Yes, there has been a dramatic change in the materials that artists employ to help them realize their inspirations.

The one element in painting that has remained constant throughout the eons, however, has been *light*. The sun remains the sun and the sky remains the sky. The same light that presented itself to the titans of landscape painting is there for you to use, *free of charge*. This is one component of painting we can't do without. We need light to paint.

In this book, I will explain some of my views about light. I'll begin our discussion with an explanation of the theory of light and my interpretation of it. Then, in the demonstrations that follow, I'll show you how the ideas can be applied to a series of painting problems. In the process, I hope to get you to think like a painter, one who happens to express himself, or herself, through the medium of watercolor.

You are a watercolorist; you wouldn't have this book if you weren't. As one who has worked with the medium, you are aware of its great benefits, permitting you to get the simple effect, and to set down a quick statement. Watercolor makes it possible for you to be spontaneous, to pare a subject to its essentials. In the following chapters, you will see why watercolor is a perfect medium for catching effects of light; it's a medium that's fresh, alive, and responsive to the moment and the shifting moods of nature. It transforms your imagination to reality.

Betty Lou Schlemm
Rockport, Massachusetts

Materials

*B*efore we get into the subject of light and its uses in painting a watercolor, let's quickly discuss our basic materials.

EASEL. I like to use the Winsor & Newton sketch easel when I travel (it can actually fit into a suitcase) because it is very light. When set up for painting, the legs have a decent spread which assures a comforting measure of stability. When painting outdoors, I weight it down against wind gusts by tying one of the legs to an old pillowcase filled with rocks. Aluminum easels on the market are far less expensive than the sketch easel, just make sure you get one that has a brace joining the three legs. This brace makes a fine support for your paint box (helps to anchor the easel also) and you can even place a board upon it, attached to the back leg, to hold your palette and water container. I also use a French sketch-box easel when I don't have to carry it far. It's a great easel but ever so heavy.

PALETTE. I use the O'Hara Palette (designed by the late Elliot O'Hara, a well-known watercolorist). It has places for paint along the side and a rectangular area for mixing — just like an oil painter's palette. A sweep of a wet brush cleans it. It's a comfortable palette, big enough to work on, yet small enough to hold in your hand. When I travel, when using the French easel or when doing studio work, I use the John Pike Palette. Both the O'Hara and Pike palettes work the same; the only difference is in size.

DRAWING BOARD. A piece of *tempered* Masonite makes a good waterproof board for mounting your paper. Be sure to get the tempered board which is used by builders for outdoor construction; it resists moisture because it's treated with oil (the *untreated* Masonite is the surface that oil painters use as a painting support). Handle your board with utmost care; don't bang it, cut into it, or do anything to its surface to damage it.

WATER CANTEEN. A watercolorist needs water and plenty of it. Many students start with a cupful. That will never do. A perfect water container, I've found, is a two-litre plastic soda pop bottle. I cut the bulk of the bottle away, leaving me with a five-inch "bucket." I punch holes on opposite sides of this container and string through them either some picture wire or nylon fishing line. I hook this line over some hardware on my easel, close by to where I rest my palette. I store extra water in a large plastic storage container, such as a large soft drink bottle or a plastic gallon container that once held milk.

RAGS. I use old terry cloth towels rather than paper towels to take water off my brush; they're stronger and more absorbent. So don't throw your old towels away. With most of the nap gone, your towel may not be satisfying after a bath, but it makes a splendid rag for painting. When I paint, the brush always goes directly from the water into the rag. How long I hold it there determines the character of my stroke.

PENCIL. The point of a hard pencil (2H and up) digs into your paper. And the lead of a very soft pencil (3B and up) could dissolve and dirty your washes. Do not use any pencil harder than an HB or softer than 2B. I prefer the 2B pencil and can vary its darkness and lightness by the pressure of my hand on the paper.

KNEADED ERASER. A standard pencil eraser is so hard it may hurt the surface of your paper. A soft, kneaded eraser is safer and more satisfying to use.

SPONGE. Never use tissues, rags, or a synthetic sponge to clean your paper. They're much too harsh. A natural sponge treats the paper as it should be treated. Some professional watercolorists buy make-up sponges, readily available wherever cosmetics are sold. Compared to the price of synthetic sponges, the natural variety is quite expensive, but the extra expense is well worth it.

BRUSHES. Nothing is more personal than the choice of brushes. And nothing is as expensive to the watercolorist as are brushes. A very good general, all-around brush is a one-inch chisel-edged brush that has a bevel-edge at the tip of the handle (for scraping and squeegeeing color). Most brush manufacturers make this brush. You have a choice of red sable, sabeline or synthetic.Get it in sabeline which, contrary to popular belief, is not synthetic. Sabeline is a light ox hair (from the ears of oxen and surprisingly soft) that is dyed the color of red sable, hence the name. The difference in price is quite dramatic. The flat brush can cover areas quickly, giving you speed when you're working outdoors. Some people use two- or three-inch brushes and put down washes that look as though they'd been made with a roller. But I prefer a more personal sort of stroke, a stroke that lets you feel the artist moving with the paint. Of course, I can't do everything with a flat brush. I also have rounds: Nos. 10, 8, and 4. The round is a sensitive brush and gives you an "artistic" line. If you can only afford two brushes, get a one-inch flat and a No. 8 round. I use sabelines exclusively. If you take good care of your brushes, washing them regularly, there's no reason why they won't last for years and years.

PAPER. If you want to economize somewhere in your painting studio, please don't do it in the area of paper. After all, it's your paper that will carry your creative energies and abilities and will be emblematic of your labors. Paper comes in various grades and textures. Get a 100% rag paper made from cotton or linen rags. You'll need a paper that holds a wash when you glaze over it but which isn't so absorbent that the washes are impossible to remove. You'll want a paper that will take corrections easily and well. Watercolor paper is made in three basic textures: hot press, cold press and rough. Most popular weights: 90 lb., 140 lb, 300 lb.

Hot Press. The surface is smooth and hard. Not recommended for beginners. When you glaze over a wash, it immediately lifts. Hot press paper works if you paint direct, but if you prefer to work one wash over another, you will be frustrated.

Cold Press. Medium texture, more rough than hot press. Cold press paper varies from one manufacturer to the next: some are heavily sized so that the paint stays on the surface; others have less sizing and are therefore more absorbent.I like Waterford cold press paper, available in many art stores or art supply mail order houses.

Rough. This texture takes big washes. The first wash settles in the valleys of the paper; later washes catch the upper surface, creating interesting rough brush effects. You have to be careful with your first washes, however. Skimp on your water and you'll leave flecks of white paper everywhere. And these spots of paper will destroy your big light-dark patterns.

A Note About Corrections: *I prepare a paper for corrections by sponging out all the areas to be corrected. I let them dry completely before repainting. This can't be done successfully if you have scraped the paper because dark, unpleasant lines will appear.*

Rice Paper. This is a specialty paper. It softens lines and automatically harmonizes your picture, but the effects are far too accidental. Be in control when you work; with rice paper everything depends on chance. I don't like rice paper; I feel as if the paper were using me instead of my using it.

Palette

When I started to paint in watercolor, every space on my palette was filled. Since that time, I've steadily simplified my choice of colors. If one pigment can do the work of two or three, then that's the one I use. I now feel that my palette is reduced to the absolute minimum. Yet, there's nothing sacred about these colors. If they all went off the market tomorrow, I could develop another workable set. So try my palette of colors, but don't be afraid to experiment outside it. *Remember, your choice of color is very personal.*

GARDEN LIFE. 40 X 25", Pastel and Watercolor.

In this combined pastel-watercolor, I wanted to show the life and movement of objects in a garden. I used many diagonals not only with the flowers and pots — combining one implied line leading to another — but with the twigs twisting and turning into each other. The foreground was made with the open and closed areas of the patterns the twigs made as they twisted over each other. A closed area is that which is formed by all four sides holding a negative shape together (very powerful and brings your attention to an area). The twigs that are not completely closed in but opened at one or two sides have not the force and allows you to move on as you view the painting. Winslow Homer, in his great painting of the Adirondacks Guide, *shows this design motif beautifully as does Mondrian's drawings and paintings of trees. This still life was done in a full value range, from white to darks, dark appearing as black with color. A mood is created because the warms dominate the color of the whole work.*

QUALITY OF COLOR.
I use colors that have been carefully tested for permanency. All reliable brands will give you this security. I buy only tubes, never cakes of color. All my colors can be sponged off the paper. Cadmium Yellow is the only one that gives me trouble in this area.

OPAQUE COLORS.
When discussing my colors in more detail, I'll mention which are opaque and which transparent. As their classification suggests, opaque colors lack transparency when used heavily in a wash. Sometimes such opaque spots add to a painting; a little opacity accents the transparency of the other washes. But as a general rule, I use a lot of water when working with opaque colors. That way, I can always feel the paper through the wash.

If I'm so interested in transparency, why don't I drop all the opaque colors? It could be done. But I like to mix transparent and opaque colors together. The heavy colors settle, the washes break up, and the result — as we'll see later in the demonstrations — is an interesting "broken color" look. Paint and water can do beautiful things, if you just leave them alone.

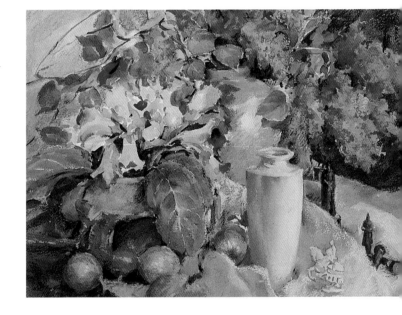

WHITE VASE AND CHESS PIECES. 22 X 30", Pastel and Watercolor.

A watercolor with pastel added is, for me, a favorite way of working; I learned about this technique from looking at many pastels of Edgar Degas. I put the watercolor in first and then, I start working up in pastel forms that are closest to me. Working in this manner allows me to keep building up a painting and to make sincere studies of light, color, air and space. The white vase, because of its strong position, commands attention and becomes the subject of this painting. Please notice the space between this vase and the traveling light as it moves into the background.

ARRANGEMENT OF THE PALETTE. *Figure 1*

shows how I set up my palette. The colors move from the lighter to the darker colors, with my most brilliant colors on the top and my earth colors (the browns) on the bottom. The colors on the top also move from warm to cool.

The "warm" colors are the colors you associate with the sun. The sun is yellow, and the warm colors are therefore yellow, as well as orange and red. In the shadows, you naturally feel quiet and "cool." The cool colors are the various forms of blue. Green is an in-between color; it can be either warm (yellow-green) or cool (blue-green). Of course, some warm colors are "cooler" than others, and a blue may be "warmer" than its neighbor. In *Figure 1,* for example, both colors 1 (Lemon Yellow) and 4 (Alizarin Crimson) are warm — but Alizarin Crimson is duller and "cooler." Similarly, both 5 (Cerulean Blue) and 7 (Ultramarine Blue) are cool, but while Cerulean Blue may be brighter, Ultramarine Blue, tending toward violet, is warmer.

The related colors are grouped together on the palette; one color can spill into its neighbor without hurting it. The blues are also together — as are Yellow Ochre, Raw Sienna and Burnt Sienna, all similarly colored. Spaces separate each group of colors. The corners are empty. When I use the palette, I angle it so the water runs out the lower right-hand corner. The palette thus becomes self-cleaning, and I don't have to worry about dirtying my brilliant reds and blues.

THE COLORS. I use the following colors in my palette:

1. **Lemon Yellow** *(opaque)* is a soft color, especially useful when mixing nature's quieter greens.

2. **Cadmium Yellow Deep** *(opaque)* is a much more brilliant, forceful yellow. It is strong and lively, so strong that I always use it with a lot of water. It is probably the most opaque of all my colors. When you use it, make sure you change water frequently. Its sediment accumulates in the water and can dirty later washes.

3. **Cadmium Red** *(opaque)* is a very warm color. It mixes beautifully with my other pigments and, to me, has a look that's reminiscent of nature. An alternative is Grumbacher

Red, a brilliant red that stays neutral. I also use Cadmium Red Deep which gives me wonderful darks and is pleasant in the lighter washes.

4. **Alizarin Crimson** *(transparent)* is a clean color, useful when painting dark areas. It makes lovely grays, and a beautiful pink when mixed with Lemon Yellow. Alizarin Crimson is a staining color but it can be sponged off the paper if necessary.

5. **Cerulean Blue** *(opaque)* is a clean, bright, sky blue with greenish tones.

6. **Cobalt Blue** *(semi-transparent)* is the coldest color on the palette. It mixes well with the other blues. It makes good grays, is useful in dark areas, and works well in skies. In short, it's a color all watercolorists like.

7. **Ultramarine Blue** *(transparent)* is a dark, warm, reddish blue. I usually reserve it for the end of a painting, when I want to give the composition some extra punch.

8. **Yellow Ochre** *(opaque)* is a quiet color, good both in grays and for softening other colors. It's also useful when painting greens, sand color, rocks, and so forth.

9. **Raw Sienna** *(transparent)* is an essential color. It's the strongest transparent warm color we have, just as Cobalt Blue is our coolest blue. We need the two extremes — the warmest and coldest — to influence all the other colors on the palette. It's been my experience that when art supply stores are low on their watercolor stocks, they will first run out of Cobalt Blue and Raw Sienna. Everybody likes them.

10. **Thalo Green** *(transparent)* is in the family of phthalo-cyanine pigments. This particular color name is proprietary to M.Grumbacher. Other manufacturers have this same pigment under different trade names. No matter which one you get, you'll find that it's an extremely strong color. It's a strong green, and I never use it by itself. Add Raw Sienna, for example, and you get a warm, light green. Add Burnt Sienna, and you get a warm, dark green.

11. **Burnt Sienna** *(transparent)* mixes well with all the other colors. It makes good darks and also warms up darker pigments. Alizarin Crimson, for example, can often be too cold by itself. A touch of Burnt Sienna picks up the color.

12. Chinese White. I put it in the empty space next to the Lemon Yellow, and remove it as soon as I'm finished with it. Leave it on the palette, and it gets into everything, deadening all your color. I mix Chinese White with colors that express the light, from the source of light or the overhead blue light of the sky. Let us say Cadmium Red Light with mostly Chinese White sends the horizon far back into the painting's depths. When I do this I then touch all top planes, catching the light with this opaque color. I can also help with the light of the painting by adding Chinese White to Cerulean Blue or Cobalt Blue. This is the cool light from the sky and again, with this color, I touch all top planes or rounded forms of trees, rocks, grass as it goes to the horizon, etc. We can see the use of Chinese White so clearly in John Singer Sargent's seascapes, boats and sails. Chinese White is a very useful color and when used in this way it is called "body color." I use Chinese White only in painting the color of light or reflected light of the sky and water.

You have no doubt noticed that black is missing from my palette. I once used the popular Payne's Gray. But I can still remember Norman Kent, the esteemed, late editor of *American Artist,* pointing to parts of my work, exclaiming "Payne's Gray! Payne's Gray!" He could see the color in all my mixes. I'd use it whenever I needed a gray. I never looked for the special quality that distinguished one gray from all the others. Payne's Gray was just too convenient. I've since learned that even grays have character.

In order to mix "black," I make use of three colors: Alizarin Crimson, Thalo Green and Ultramarine Blue. Since you should always be able to see into your darks — that gives them life and air — I make sure that all three of these dark colors are transparent. I don't want an opaque black. I usually vary my darks by mixing any three of these colors, with one predominating. Thalo Green and Alizarin Crimson, for example, make a black right on the nose. A touch of Burnt Sienna adds variety to it. Thalo Green and Ultramarine Blue also make a good dark. Alizarin Crimson can be added to give it extra life.

SPECIAL COLORS. Special situations call for special pigments. When I'm doing flowers, for example, and want pure, clean, intense color, I add Cobalt Violet (warm, and light) and Winsor Violet (cool, dark, and very transparent) to my palette.

Different kinds of light also call for new colors. My present palette is well suited for working in New England. When I painted in Arizona, however, the clear, harsh light made me add Naples Yellow — it helped me express my feeling for the locale. That's why it's wise to experiment with your palette. You may discover something that will help you grow as a painter.

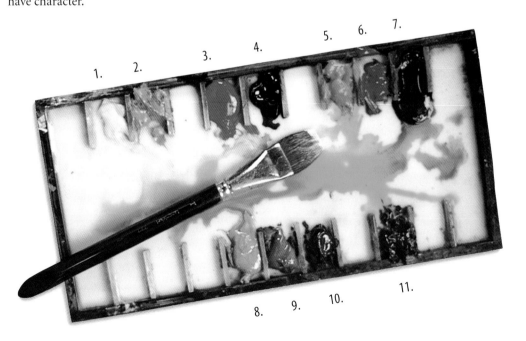

FIGURE 1. MY PALETTE.

1. Lemon Yellow
2. Cadmium Yellow Deep
3. Cadmium Red Light
 (or Grumbacher Red)
4. Alizarin Crimson
5. Cerulean Blue
6. Cobalt Blue
7. Ultramarine Blue
8. Yellow Ochre
9. Raw Sienna
10. Thalo Green
11. Burnt Sienna

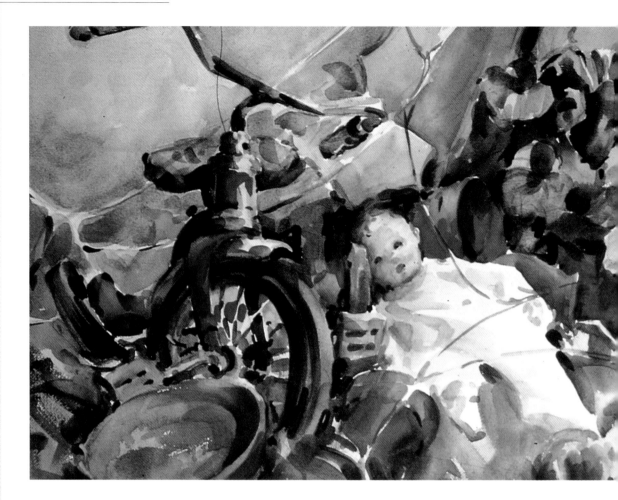

Light is the life of a painting. After years of painting outdoors, I've come to certain conclusions about how light behaves. I'll first discuss my general ideas about light and then, in the chapters that follow, describe the way it relates to my use of watercolor washes. We'll then proceed to a sample demonstration and see how my ideas are applied to a number of practical problems.

JENNIFER'S BICYCLE. 18 X 24"

I painted this picture after my niece, who had spent a week with me, had left for her home in another state. I tried to take advantage of the expressive use of shadow by placing the toys in an area of the garden where the light showed through the many objects. I wanted them to seem discarded. They're no longer used — and the feeling of activity has now shifted to the quiet distance. Where there's light, there's life.

SOURCE OF LIGHT. Traditional painters usually look at light in one of two ways. They prefer either what I call a "one-source light" or a "two-source light" — the light of the sun and the light overhead us, which is the sky. To help you understand the basis for my approach to light, I'd like to compare these two approaches.

One-Source Light. When a spotlight is placed very close to a still-life, the spotlight dominates the setup. At this distance, the highlights are sharp and well defined and the areas not struck by this light (the shadowed areas of the object) are dark and nearly colorless; they tend toward almost black. These deep, almost impenetrable darks are what give both form and drama to paintings done in the one-source manner.

As areas of an object move away from this single, strong source of light, you darken the shadow by touching it with the complement of the object. If the object is green, for example, you add red to the areas that move away from the light, those areas that turn into shadow. If it's yellow, you add purple; if blue, you add orange. And vice versa in all three cases. The complement darkens and grays a color without changing that color's basic character. If the object is purple, for example, adding the complementary yellow (a color high in value) as it moves from the light would lighten the color rather than darken it. In that case, you'd have to darken the object first with a darker version of that color, and then add the complement so you can feel it in the areas away from the source of light.

Such cases are special, and practice with the medium will teach you how to handle them. The point I want to emphasize is that by using complements you do not change the character of your color. And that keeps you from making a mistake often seen in student work: the apple painted red on the lighted side and brown on the dark side. Such an apple looks as if it were made of two different materials.

In *Figure 2A,* I painted an apple with the spotlight close to the object. Because the right side of the apple is nearest the light source, the bulb's warm, yellow-orange color affects the apple's shiny surface. As the round form of the apple turns from the light, I add green, the complement of the red in the apple. You can't see the complement in the mix, but it turns the red almost black. The result is a very solid, sculptural form.

FIGURE 2A.
ONE-SOURCE LIGHT: Although light colors the areas nearest to it, the shadows all go quickly to almost black.

Two-Source Light. If you move the spotlight much farther away from the still-life, the source of light naturally has a less powerful effect. There's still a clear value difference between those areas hit by the light and those out of the light. But now there's also a color difference. The farther away the light is, the more obvious these differences. And it's this color that I find so interesting and exciting. Where does it come from?

Those areas hit by the spotlight — what I call the "main light" — are still warm. But the areas in darkness are now affected by the color of the rest of the room, what I call the "allover (or overall) light." These are the two main parts of a two-source light: the main light and the allover light. In a room, this allover light can be a fairly complex mixture of colors. Part of it may come from an incandescent or fluorescent lamp in a corner; part will come from the color of the walls and the woodwork; part will come from the color of the outdoors as it streams in through a door or window. In nature, the situation is a bit more straightforward. The main light comes from the sun and is usually warm, while the allover light comes from the rest of the sky and is usually cool. We'll soon explore these relationships more fully.

In our still life demonstration, we darkened the apple by adding its complement. We still do this when using two sources of light. In addition, however, an area moving away from the source of light also begins to take on the complementary color of that light. The farther a part of an object is from the light, the more obvious the complementary color becomes. To further explain this, I'd like to tell you about an exercise I can remember from art school in which the instructor turned a red spotlight on the model. The shadows on her body all went green. If he had used a green light, the shadows would all have been very red. If he had moved the spotlight very near the model, however, the light would have been overpowering and, as before, the darks would simply have gone to near black. The green showed with particular clarity because the walls of the studio were relatively neutral in color. Theoretically, these walls provided the allover light in the room, but they weren't colorful enough to affect the dark areas.

In *Figure 2B,* the strong light is mainly coming from the blue sky as it enters the room through a nearby window. Using the same standard yellow-orange bulb to illuminate the apple, I move the spotlight back so the "sky" light can affect the shadows. I then add the complement (green) to dull the apple in the area less strongly influenced by the light. I also add some blue to the dark area, a blue that is complementary to the light. And on the far left side of the apple, I show the strong influence of the cool light from the window.

Remember now that if I had used a blue bulb on the same apple, the area hit by this main light would be cool and the area not in this light would be warmer.

While less dramatic than *Figure 2A, Figure 2B* looks more natural to the eye; you feel that the form exists in light and air. And in the following discussion and demonstrations, we'll see how this idea can also be applied to landscape painting. In fact, it's in landscape painting that it has received its finest expression. The Impressionists — predominantly outdoor painters — were the first to make a careful study of the interesting visual effects created by the sun and the sky and the warm light and cool shadow. The results of their investigations can be seen with particular beauty in the work of two of the greatest students of light: John Singer Sargent and Joaquin Sorolla y Bastida. You can read textbooks about color, if you want — but you'd do better to study the work of these two masters.

FIGURE 2B.
THE LIGHT OF THE SUN AND THE SKY: The warm color of the apple is from the sun playing on its form.
The cool light of the sky is affecting the form as the apple turns completely away from the warm sun.

THE INFLUENCES OF LIGHT.
As you can see, I prefer using the light of the sun and the sky, and that's the approach we'll explore in this book. In order to make it easier to talk about light, I have decided, rather arbitrarily, to list nine ways that light influences objects. They are as follows:

1. **Moving away**
2. **Turning away**
3. **Out of the light**
4. **In the light**
5. **Reflected light**
6. **Cast shadows**
7. **No light**
8. **Translucency**
9. **The gray days**

These are my own categories, the result of many years of outdoor painting. Of course, there aren't nine neat categories in nature. The effects of light are all inter-related, like the fingers of two hands clasped tightly together. Trying to isolate each element is very difficult. If you find my exposition confusing at times, the best solution would probably be for you to continue reading until you've begun to get a sense of the categories as a whole. You'll then be better able to relate one to the other.

I should also note that I don't expect every visual phenomenon to fit somewhere under my headings. There are no absolutes in light; like people, light can do funny things. I just want to show you a few fundamental ideas, ideas based not on an abstract theory but on the way nature actually behaves. Don't memorize these influences; they are not a way to pigeonhole nature. On the contrary, they should make you close this book, open your front door, and take your own look at the world. I'm suggesting things to look for; you'll have to make the big discoveries on your own.

TWO PRINCIPAL SOURCES OF LIGHT.
The basic light on a subject comes from two sources: the main light and the light of the sky.

The Main Light. I use the term in light to describe those areas which are most directly influenced by the light from the sun or from a bulb. On the average sunny day — to use a particularly obvious example — areas hit by the warm sun naturally take on a warm coloration. In *Figure 3,* for example, you can see the warmth of all the surfaces facing the sun: the warm foliage, the warm earth, the warm roof of the house. Since nothing is as

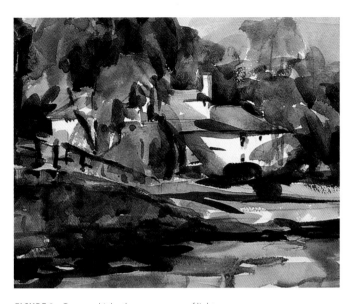

FIGURE 3. Trees are hit by the warm source of light.

brilliant as the white paper, I let it stand for the house in light. I'd only dull it by trying to glaze over the area with a warm color.

The Light from the Sky. On a clear day, the color of the sky touches all the top planes and is seen everywhere in the painting. Snow being white shows the affect of the sun but also on the flat planes, as they recede into the distance, the cool light of the sky is added. The cool light, or that colored light what ever the sky may be, touches everything that is not directly affected by the main light which is the sun.

MOVING, TURNING FROM THE LIGHT.
Now that we've discussed the two basic sources of light, we can look at the effect the light has on objects moving in space.

Moving Away in the Light. Although sunlight is distributed evenly over the landscape, wherever you happen to be standing usually appears to be the spot where the sun is shining most strongly. In a landscape, the dust and moisture in the air accumulate to form what the great painter and teacher John F. Carlson calls the "veils of atmosphere", the cause of what is commonly known as "atmospheric perspective." The material in the air prevents the color of distant objects from coming to us in their full intensity. In *Figure 4,* the spotlight is aimed toward the center bird but the warm light also hits the cloth and flower and is even felt in the air of the background.

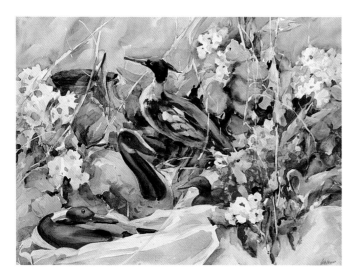

FIGURE 4. The spot light is aimed toward the center bird.

FIGURE 5. The rounded parts of the drape in the foreground turn away from the source of light.

You've seen how objects, as they move away from you, gradually appear to become duller in color. They tend toward a neutral, that is, warmly colored objects become slightly cooler in color, while cool objects become slightly warmer. In this interaction, the warm and cool colors eventually cancel each other out, so that the farther back in space an object is located, the less color you can see in it. Each color holds its identity to a different degree. Yellow loses its identity very quickly; white remains white for quite a long time. But no matter how far back in the landscape a sunlit object is, or how much its color identity is lost, it always appears to be influenced by the sun.

A somewhat similar effect can be seen within the geography of a still life. Since the light is concentrated on a limited area, you can see more clearly how its strength lessens as objects move away from it.

Turning from the Light. When I talk about an object moving away in the light, I refer to both (1) the amount of atmosphere between the viewer and the sunlit object and (2) the distance between the source of light (a spotlight) and the object it influences. In both cases, I'm concerned about the spatial positions of objects directly affected by the main light. The term "turning from the light," on the other hand, is applicable primarily to curved surfaces exposed to a raking light, rather than a direct one. The sun comes up and lightens the sky. Filled with luminous light it reflects down and lightens the earth's planes not in shadow and not yet directly hit with the sun. In *Figure 5,* the rounded parts of the drape in the foreground, moving

across the table to the distance, all turn slowly away from the light. The light hits them on an angle. Pay particular attention to where the drapes are directly in the main light, it's quite warm; but even the areas curving away from the light have a lot of warmth and color in them.

As I noted earlier, the complements (1) of the light and (2) of the color of the object both begin to have an influence as an object moves away from the main light. The effect increases as the object turns from the light. As our apple turned from the light, for example, it began to get (1) slightly darker in value since it was no longer strongly illuminated; (2) slightly grayer, since the red naturally became duller (green was added to the mix); and (3) slightly cooler, as the warmth of the light began to lose some of its force. Such an area, however, never becomes as dark as the part of the object entirely out of the light. If you painted it that dark, you'd destroy the basic light-dark divisions of your picture and, thus, the truth of your statement. Remember: areas influenced by the main light must always look as if they're influenced by this light, just as areas not influenced by the light must always appear to be out of the light. That's why an object, as it turns from the sun, may become cooler, but it will never cross the line that separates warm from cold color. As soon as it becomes cold, it ceases to be an area influenced by sunlight.

Out of the Light. Once an object has completely turned from the main source of light, it is, of course, out of the light. The main source of light cannot hit it directly. The area is therefore

duller and darker than the part of the object in light; it also shows, most strongly, the influence of the complementary color of that light. In *Figure 6,* the house on the right is in light; the one on the left is clearly out of the light — that is, it's at such an angle to the sun that sunlight cannot touch it directly. As we've already noted, this side would naturally show some cool color — the color that's complementary to that of the main light. In this case, the effect is exaggerated by the fact that the house also catches a lot of cool color from the overall light of the surrounding sky.

I should note that under normal conditions, the out-of-light side of a white house is always darker than the sky. Many students have trouble with this fact; they know how white the house is, and they want it to look white, even when it's not hit

FIGURE 6. The house on the right is in light; that on the left, out of the light.

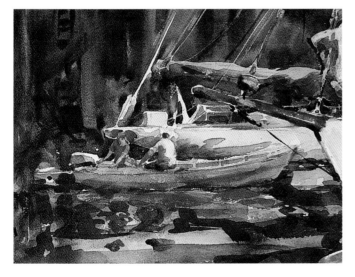

FIGURE 7. The sheltered area under a wharf is out of the light.

by the sun. The coolest out-of-light edge is usually found nearest to us at the point where the in-light and out-of-light sides of the house meet.

Figure 7 shows a different sort of out-of-light spot — the sheltered place under a wharf. It's like looking into the inside of a barn or through the door of a house. Although light has trouble getting into it, the space is far from pitch black. There's air in it, and you can see into the darks. They're transparent. Since there's little light to create value contrasts, the edges are soft, quiet, and mysterious.

ADDITIONAL CONSIDERATIONS. If you've looked closely at the previous illustrations, you've probably noticed colors that can't be explained by a simple reference to the influences of either the main light source or the allover light. Much of this additional color is the result of:

Reflected Light. When light hits an object, it bounces off it, sending color into surrounding areas. When the object is shiny but relatively colorless — like the ocean — it merely acts as a mirror and reflects the color of the sources of light. In order for one object to reflect light into another, however, it's not at all necessary that either be particularly shiny. If you wear a red wool shirt, the red from that shirt will bounce up under your chin: the warm color will be clearly visible. Similarly, light hitting grass and foliage will send warm green color into the in-light and out-of-light areas of a house. Nature is full of such examples.

Depending on the nature of the day, reflected light can be either a very important part of your picture — or a quite negligible one. The strong light of a clear day, for example, reflects color into everything. At a beach, the brilliant sun bounces light off the sand into the surrounding darks, obliterating them. On a very dull day, however, such effects are more subtle; the reflected light is much harder to see.

The same principle applies to work done indoors. The color reflected into a still life from the walls of the room is really a form of reflected light. If there is no strong secondary source of illumination — like the blue sky pouring in through a north window — then the reflected light of the studio walls can, in fact, become your allover light.

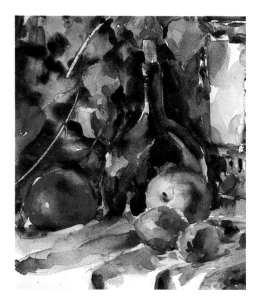

FIGURE 8. The bottle catches reflected light from a variety of directions.

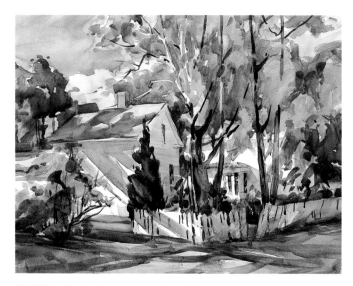

FIGURE 9. Cast shadows appear on the road, house, and trees.

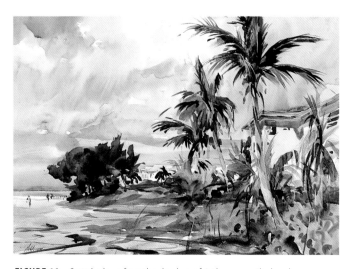

FIGURE 10. Cast shadows from the clouds are faintly seen on the beach.

Generally speaking, objects have to be fairly near one another for the reflected light to have an effect. In *Figure 8,* for example, the green bottle, while strongly colored itself, also shows the color reflected into it from the nearby red apples and from the orange background drapery. The color of these red-orange accessories is so strong that it even reflects down onto the top of the white cloth on the table. Neither the cloth nor the accessories are "shiny" — but you can still see the effect of the reflected light.

Cast Shadows. We've seen how reflected light can warm both the in-light and out-of-light parts of an object. A cast shadow, on the other hand, tends to block out reflected warm light and thus creates some of the coolest areas in our picture. While an out-of-light area can have a lot of warmth in it, a cast shadow can only go from a cool to a neutral gray. It can never be warm, for it then ceases to be a cast shadow. The amount of color you see in a cast shadow depends on two main factors:

1. The closeness of the objects casting and receiving the shadow. This is the primary relationship. The nearer the objects are to one another, the less chance sunlight has to creep between them. The cast shadows thus become dark and cool.

2. The intensity of the light. If it's a bright, clear day, the shadows will be darker and more colorful than on a hazy or dull day. The complementary color of the light will be more clearly seen in them.

When I paint cast shadows, I use a fairly simple procedure. I start with the premise that cast shadows are all the same color: the complement of the light. How strong this color is depends, again, on the intensity of the light. I don't paint my cast shadows until the picture is almost done. I then take the shadow color and lay it on the paper in a transparent glaze. Since the shadows are glazed, you always feel the color of the first washes beneath them. You sense the materials that the shadow is covering.

In *Figure 9,* you can see cast shadows on the house, the trees, and the foreground road. Notice particularly the warmth of the glazed shadow in the lower right-hand corner. You can feel the color of the road coming through the shadow, though the shadow remains cool. In *Figure 10,* the shadows on the sand are cast by distant clouds. The shadows are therefore light

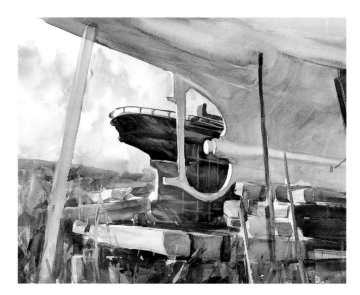

FIGURE 11. The out-of-the-light, or no-light areas, are clearly seen here and also that glorious reflected light that gives us so much color in the shadows underneath the large white boat.

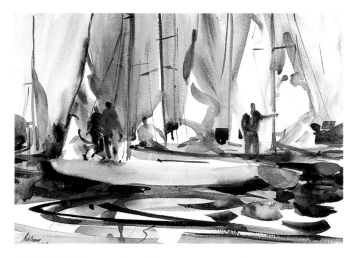

FIGURE 12. Light comes through the semi-transparent sails.

in value and soft-edged. In the background, however, a grove of trees casts very dark shadows on the green bank. The foliage of these trees acts as an umbrella and prevents light from working its way into the shadows. They remain dark and cold.

No Light. When objects are very close together, the spaces between them are unaffected by the source of light, the light of the sky, or any reflected light. I call such spaces "no-light" areas. In *Figure 11,* for example, the crevices between the great logs supporting the boat, and the darker values under the large green boat, are the no-light areas.

Translucency. Light coming through a translucent or semi-transparent material is darker in value than direct light, but still very intense and warm. It's a beautiful kind of light. In *Figure 12,* for example, you can see this warm light filtering through the sails.

A SPECIAL CASE: THE GRAY DAY. The gray

day presents a particularly interesting and elusive light problem, and I'll end our discussion of the influences of light by taking a few minutes to talk about it.

On a gray day, we have what could loosely be called a one-source light. The clouds diffuse the light of the sun so that we have a single allover light. This light radiates down from the sky, striking mainly horizontal and slanting planes.

To understand what happens on a gray day, let's think, for a minute, about light on a bright, hazy day. On such a day, the moisture in the air affects the sunlight exactly as it affects distant sunlit objects (atmospheric perspective). In passing through the heavy atmosphere, the light becomes duller. It loses some of its intensity; that is, the light actually becomes slightly cooler in color. The difference is very subtle, however, and you still have a strong sense of the sun's warmth.

This effect is greatly exaggerated on a gray day. The clouds and moisture become so heavy that (1) the sunlight is diffused throughout the sky and (2) the light, dulled by the moisture, becomes cooler, sometime almost colorless, but still we must feel a slight warmth to it. No matter how many clouds, no matter how much moisture, it would be black if there were not the sun behind all of this to light the world.

To further understand this light, let's look at its effect on a white house. Strictly speaking, a white house on a gray day is out of the light. It's a mass, all sides of which are darker than the sky. In fact, however, one of these sides is usually cooler than the other: that side nearest to the area of the sky hiding the sun is slightly warmer. The other side of the house is slightly cooler, following our general rule that an area that's not influenced by the dominant light will take on the color that's complementary to that light. One side is simply warmer — perhaps by only a hair — than the side not influenced by the diffused light of the day.

Landscape Light

At the first crack of dawn, that crack when a green-yellow light appears on the horizon, the sun rises on our landscape and the earth is lit with a very light greenish yellow color. At first it comes from the horizon and then moves ever upward into the atmosphere, filling this atmosphere until the soft, light, greenish blues appear in the sky. As the day goes on into later morning, the green-blue color turns into a pure light blue and reaches to the zenith, that wonderful sky over our heads. Then it becomes filled with light and appears to be a violet blue.

We are out in that glorious light of the world — where we will experience nature in all its many moods — from early morning until the hour when only man-made lights are left. It is now noontime; the sun begins its move to the western horizon and becomes more orange-yellow as it heads towards its inevitable daily retirement. The sky is so filled with intense light that this light takes on a warmer color than the morning and the shadows become also more colorful and darker. Soon, the yellow orange turns slowly to a red orange and suddenly, it is gone. Our special day is over; there will be other days.

What of those days when the sun doesn't shine? When it is diffused by clouds filling the sky? Well, the sky is always there with the same light, but the color of this light becomes many tones of pearly gray. On days like these all earth tones are darker.

And what about the days that are dominated by huge cumulus clouds? The underside of the clouds become dark and the shadow sides of these clouds are gray and warm grays.

There are also bright, warm whites where the sun is hitting. Underneath and around these clouds are the rosy colors of the horizon: the greenish blues, true blues and the violet blues of the zenith. As the clouds recede toward the horizon, they are farther away from us, therefore the darks underneath become lighter and cooler.

As you have just learned, nature is always changing and we, as painters, must observe and paint each color and value carefully and accordingly. The earth depends on the value and colors of the sky. A successful painting of nature's vista depends on our knowledge of the role the sky plays in this spectacular drama.

We must always be aware of the affect that light has on our painting. An oil painter places his warm light color on the canvas and then mixes very carefully the cool light of the atmosphere. This color must match the value of the light color and should be painted in such a way as not to mix these two colors, laying one gingerly over the other.

Landscape Light

For the watercolor painter it is different because we must keep the light color a lighter value so as not to make the second wash look green. We are working with a transparent medium.

I do not work in the same manner in every painting but always, no matter the procedure, I think of this light as one of the most important elements of each painting. I wish it to express a time of day and atmosphere of that day. One way is the use of the "light" itself, the color of the light all over the sky. I change this yellow where the sun is in the sky, using a pure light yellow, and as we move away from the sun, I add a little red or orange — ever so lightly — to this color.

If the atmosphere is heavy, I then add a reddish tone, again, very light at the horizon. I find this so often here in New England when we have so much moisture in the air in the morning. As I do this wash, I try to work fast, never touching it if it dries. If I am lucky and the wash stays wet, I lay on the color of the blues and grays. I do this both on a sunny day or a gray day. There is always light and it is luminous. (During those occasional times when the wash dries, I still work in this manner).

On some days it would be too difficult to do this so I add the cool to the warm and put them on so as to feel both colors working together. This is achieved by never, never going into the wash again. The warm color must be put on first.

When painting clouds, this is the procedure I use: First I warm the paper slightly — a very lighter color than the light as there are white clouds so far away. We must not keep them as white paper as they would come forward in the picture plane. When this is dry, I then paint the shadow color of the clouds, constantly softening most — not all — edges. (It's important to try not to go into these washes when they are dry.) Then I paint the blues of the sky, thinly from the horizon to the zenith.

When we see the light through the atmosphere, when we see light or warms and cools working together on local color, this is called *vibration*. We may break up the color, never the value. Not doing this we would not be able to truly paint the landscape. All things, all forms are touched with the days' lights and the cools of the atmosphere. So *vibration* becomes another very important element in a painting. To achieve this these colors *must* be added when the *washes are wet* and first put on. If the wash dries we cannot then have this wonderful effect.

Space is found by working with color and values receding into the picture plane, the field going so far away from us. Another way to find space is that simple procedure of placing an object in front of another. The edge is of great importance: hard edges appear to come forward; soft edges recede and also turn round forms. *Refraction* is when, let us say, trees, rocks, whatever, go back further and further. We can paint the edge of the object (let's say a tree) that's closest to us sharp and as it goes to the other group of trees, the closest edge is hard and we blend the edge of the trees behind it. We can do this over and over, this hard edge and blended one, so that we can have virtually miles of trees, all separated and losing in color and value as they recede.

In doing this, we also must remember that the light breaks the edge. Make this light come from one direction, it is the source of light which is the sun. In breaking the edge, let us say in the roof of a house, the house is in its pictorial space and not merely painted in. There are hard edges, broken edges, soft edges, blended edges to various degrees and lost edges. The edge has to do with refraction and tells us so much about the painter. Beginners and students are not as aware of this importance as the more experienced painter is. And so, vibration expresses light and refraction tells us about air and space.

Nature, so subtle, seems to do this. The warm light gives us cooler shadows. However, so much of the cool shadows come from the sky which affects all flat planes. The sky is overhead and so it touches the flat planes whether they are in the light or shade. This arching light of the sky on each particular day has a color of its own and we must always observe this and add it throughout our painting.

I hope this all helps you to understand these important elements in landscape painting.

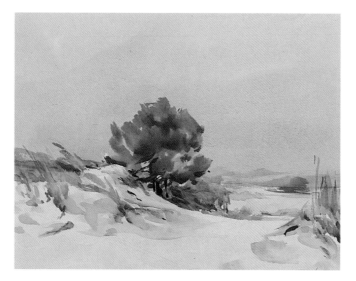

EARLY MORNING AT WINGAERSHEEK BEACH.

The beach that morning was extremely quiet. My dog and I were the only ones there. Only the soft push of surf, gently moving back and forth on the clear white sand, was heard. It was very bright, although the sun could not be seen through the cloud cover. To capture this, I mixed my warm Cadmium Red, a little Lemon Yellow and then added mixtures of Cobalt Blue and Cerulean Blue to gray down this light. I started at the horizon with warmer grays, using the Cerulean Blue and then, as the washes rose up into the sky, Cobalt Blue was added. I used a large one-and-one-quarter-inch brush and worked rapidly so as not to get any brush marks. Then I turned the paper upside down and let all the washes blend together. I was lucky; they worked perfectly. As the washes were nearly dried (just damp) I started painting again at the horizon, using a clean wash. I started the bushes and then the sand, using Cobalt Blue, Yellow Ochre and Cadmium Red to get the sand color. I darkened the color and warmed it to make it appear to come forward. I tried at this time to also create form in my dunes. We must always think form. Then I painted the grasses and dark trees. The tree was my subject (focal point) and very important to me, I placed it near center, moving slightly toward the right. This is one of my favorite paintings because it became not merely a sand dune, beach, fog painting, but one where all colors, edges, washes and values suggest the quiet mood. The mood is so necessary to this world of art; we must strive for it. Here are two other sand dune paintings:

This is later in the morning. It's a beautiful sunny day and the atmosphere is clearing. The clouds, barely seen, are floating away.

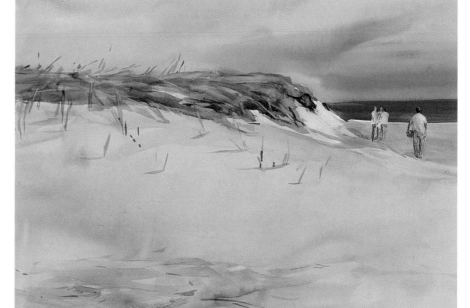

AFTERNOON ON THE BEACH.

A bright sun and clear, darker blues suggest a day that is warm and an atmosphere that is dry. I tried, in this painting, to suggest the vastness of Good Harbor Beach in Gloucester.

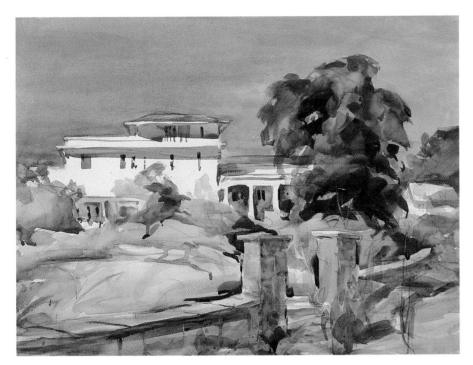

The sky is a clear, luminous dark blue. I painted with a 1 1/4" brush, moving quickly. Warm and dark at the horizon on the left and lighter and no red but yellow added to the wash on the right. The value jump of the Ralph Waldo Emerson Inn was an extremely important one. We see it so clearly because the orange roof is a complement to the blue sky.

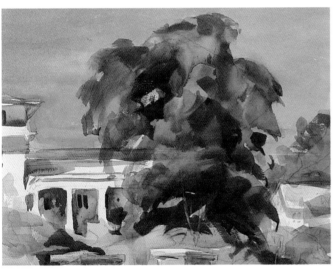

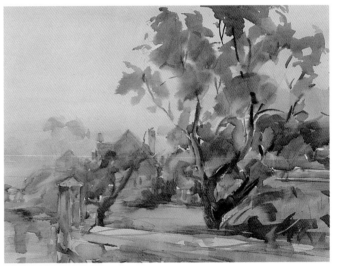

In this detail of the painting at top, I show the work that I did on the tree. I modeled the tree, so dark in this painting, always painting with warm light and using cool as it turns from the light and then very dark as we go under and through its dense foliage. See how we can enter the underneath of the porch. If the light is warm, the out-of-light areas must be cool but we break up the color in order to enter the space. If it were solid color, we could not walk through. The edges of the columns and under the roof where there is no light, became very dark and so, we used refraction here. I just darkened all around the edge and blended it to disappear in the other wash. And so, now we see how vibration — seeing color through color and refraction — working the edge, sets up the space and gives us the landscape sense.

Fog, too, is controlled by the values and the losing of the edges very quickly. As the fog rolls in we see our landscape, lose some and see it again. The tree is out of the fog and color can be seen in its bark. The top plane of the wall tells us it is wet because it appears as a mirror of the sky.

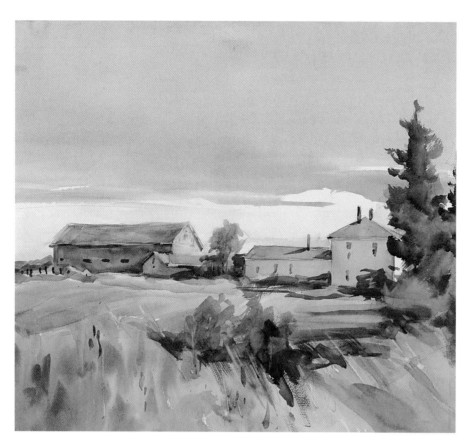

LATE AFTERNOON AT PORT CLYDE IN MAINE. *The sky seems dark in contrast to the white clouds but we must always look for the relation of the sky value to the earth and then the upright planes in shadow against it. See how very dark the trees are and yet they are not black. The biggest value jump is the dark in the center foreground against the very warm, light, tall grasses. The painting is balanced with the center dark. When we paint, we must consider the lights and darks as patterns in the composition and not just as trees, bushes, houses, etc.*

The other two paintings on this page were also painted in the Port Clyde area, Tennants Harbor, to be exact. They are both of the same scene but were painted on different days with different patterns, different values and mood. In the painting below, the day is overcast, the contrasts are not as pronounced.

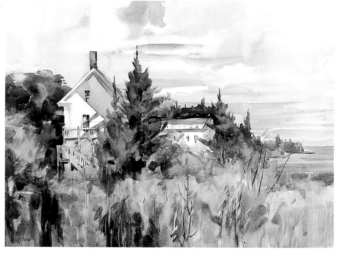

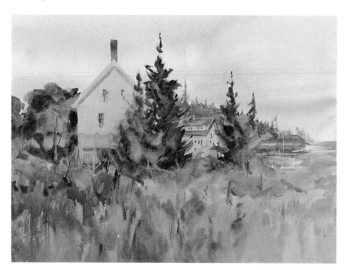

The sunny day with its great cast shadows on the white house is the subject, but we move quickly to the other white building and the white cloud above it. We then move with the lights up to the top of the painting where blue sky and white cloud touch. In controlling the values, we control the eye of our viewer and make him travel through the painting. Another point of interest in the sunny-day painting is how close we can get, in fact, feel we are standing in the dark greens and move on to eternity with the light greenish blue at the horizon. I painted this horizon color with Cerulean Blue and Thalo Green.

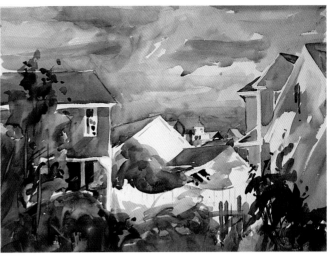

The paintings at the right and directly below were both done on the same day, same location and are exactly alike except the one below was done in the morning light; the homes are backlit and there's little contrast. Notice how the blue gate is intense in color and sets up the picture plane so we may enter the painting. The yacht club is important in its placement but the values and colors are close together to create space.

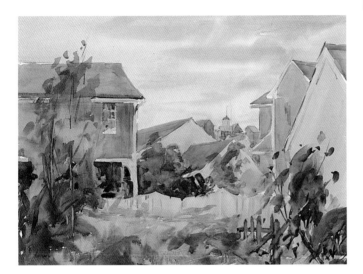

In this version, the same scene as that shown on the left, you will notice that the whites of the clouds are not as white as the houses. This is very important in the space or picture plane. I played down the values and darkened them in the foreground to show the drama of the light. The horizon was darkened to then add to the value jump of the white houses. The blue gate becomes closer in value and color to the foliage. The house on the left, with shadow on it, uncovers an art truth: white in shadow, up close, is about a fifty percent value jump from white to black. Also, we see now warm light, cool shadow.

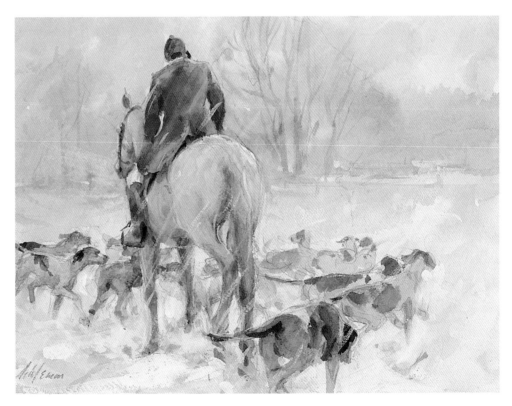

Snow presents us with even a more closely observed feeling for the values. There is much warmth in this snow painting, showing that the day is not too cold or threatening. Notice how far back the trees go.

Composition

Sometimes I wonder whether composition is or is not a matter of good taste. It seems to me that there are those who without any training can come up with the most unusual arrangements of shapes and values. They are so clever in the way they set things down.

PROPORTIONS. When I first started painting, I was aware of the importance of composition but never knew quite how to achieve a truly good one. Was I lacking in good taste? I was told to balance, watch those values, make my values read as shapes, be sure to balance my color. So much advice, but I never seemed to get a composition that was really different. The work was all right but never what I really wanted and I didn't know how to find out what I wanted.

Then, through careful scrutiny of paintings of the past, I began to find important elements of composition. Now, I believe in these as much for my painting life as I do in believing my body needs air and food to live.

Let's start with a blank piece of paper. We must activate this space. One of the oldest methods is to first find the square. This is achieved by taking the short side of a full sheet of watercolor paper (22") and bringing that over to the long side (30") and then dropping a line down to find the square which now should measure 22 x 22". A square within the picture is a pleasing division and one in which a prominent piece (a figure, tree, etc.) of the painting may be placed. Refer to *Figure 13* for five examples of squares within the picture area.

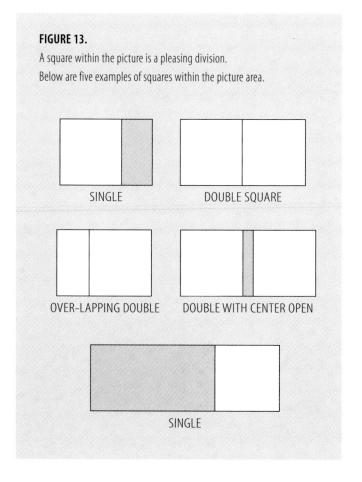

FIGURE 13.
A square within the picture is a pleasing division.
Below are five examples of squares within the picture area.

SINGLE

DOUBLE SQUARE

OVER-LAPPING DOUBLE

DOUBLE WITH CENTER OPEN

SINGLE

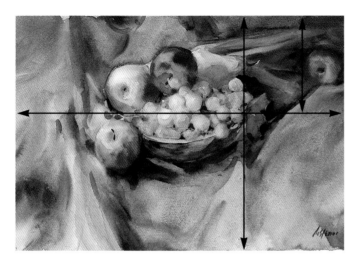

FIGURE 14.

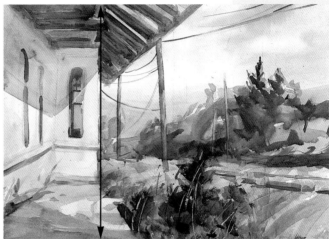

FIGURE 15.

FIGURE 16.

I want to now show you how I put this into practice into my paintings. In *Figure 14,* as I was arranging the bowl of apples, the apple far from the group became interesting to me; it represented a feeling of isolation. Great! A new thought! So I drew a square on the paper and put the bowl in this square. In another small square, I placed the isolated apple. After this was done, the folds of the drape became rather abstracted using mid-tone and dark mid-tone shapes. I added darks into these. The shapes became important and gave life to a painting that would otherwise have been perhaps boring and common

place. A look at *Figure 15,* a demonstration painting that I did in Pennsylvania, shows us an abandoned train station. I felt that the overgrown landscape was extremely important to make a statement that nothing was going to happen here. I set up the picture space by forming again a square, thus giving the station the smaller part and the lonely landscape the greater portion of the composition.

Another landscape, *Figure 16,* is so quiet, so untouched. Again, I utilized the square but I missed just a bit on the break-up of the paper; the half-opened door, however, fell on the square. This was a fortunate accident. The dark crevice of the door works well with the dark shapes of the trees next to the building. These darks command you to look there. Where the values of dark and light come together and touch with the greatest strength is usually your subject. I painted a more intense color in the foreground and the lighter, less intense greens in the background. This helped to set up the color prospect in the painting. I also used the foreground trees to lead the viewer back into the painting. I had to think of the foreground, or bottom of my paper closest to me, and placed my trees where they grew from the ground back and forth at different intervals. I moved them toward the back and then brought one forward. I again went back, making certain they did not set up an implied line, one that would lead the eye out

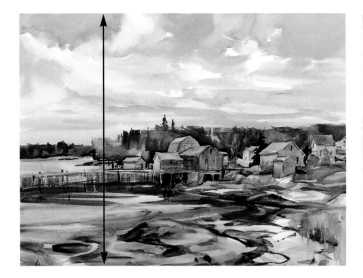

FIGURE 17.

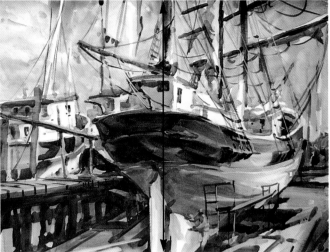

FIGURE 18.

of the painting. An implied line goes from one area of a painting to another, like the stars in the sky leading you with an imaginary line to the next shape and the next and so on, taking you finally to the outer areas of your painting or to the subject. You will find that many of these lines touch halves and squares.

In *Figure 17,* I placed the square rather quickly on this landscape painting. In the large area, I placed the whole landscape; the small area I gave to the distant water. This permits me to paint my subject and yet move through the painting into the great distance of water and to the horizon. When this was painted, I first put on a wash of the warm gray color found underneath the clouds, and with this warm gray I ran the wash through the water and also on the shadow side of the houses. However, as I painted a different area I changed the value and color of these grays slightly but kept it feeling as a family of color, different but related. We must remember, everything has its own value and color. After I did this, I cut the blue sky into the dark clouds and white paper which formed the clouds. I constantly softened the edges and graded the warm greenish blue at the horizon to the darker, almost Ultramarine Blue as we rise higher and higher into the sky. We must do this also in the water. We must have color change so a feeling of distance is achieved. The color of the sky overhead is that color you would also find at your feet in the water. I then painted the entire landscape, always thinking of the color and value as it moved from the foreground to the middleground and then to the distance.

BALANCE.
Before we continue our journey in proportions, I feel it's time right now to deal with another element of composition — balance. I can't begin to think of this subject without being reminded of how Cezanne handled balance. His approach was that of constantly setting and then upsetting the balance, followed by the next step of resetting it. Cezanne began by sketching in pencil. With the first light pencil stroke he was in effect upsetting the balance of a blank canvas. He then restored it with another stroke to reset the balance of the composition. In this way he was in control of the picture surface at all times. He also worked in this way with color. I used this idea and added my own thinking in threes:

> *The first shape is very important.*
> *The second shape is then added.*
> *The third is the balance.*

I use this idea in relating color and value. It helps to keep the painting always moving and in order.

Another way of balancing the painting is to use center lines. I have noticed that paintings have an implied line through the center either vertically or horizontally. This comes from classic art, that of Leonardo DaVinci's Last Supper and Raphael's Sistine Madonna, to name just two. However, in our days, we want to do this so it is not obvious at all. Look at all good and great paintings and see how subtly the center was used; it is always there.

Balance is like a seesaw and we all know that if a large

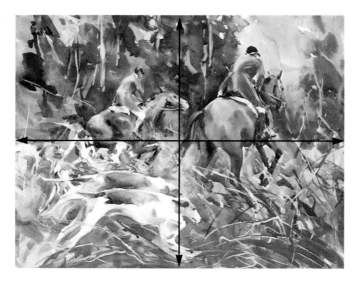

FIGURE 19.

weight was on one side, a smaller weight could balance it, using position of the light side.

Balance can also be achieved if the subject is not in the exact center but crossing over it. I've chosen two of my paintings to demonstrate this type of balance. In the painting of the old ship, *Figure 18* (page 30), wanted so much to show its strength and faded beauty, for it was still so stately. To do this I took the most important line of the painting — center. Straight down the paper my pencil moved as I drew in the mast from center top to the great rudder centered at the bottom. In fact, we enter this painting with the rudder. Every painting needs an entry and this was it. Notice how the rudder has the greatest strength because of the great contrast in values. All simplicity is surrounding it. I always keep areas around my subject quiet. If it gets too active, we will not see the subject. The edges here are sharp, showing strength. I painted this at the old docks of Rocky Neck in Gloucester.

In *Figure 19,* the center was used to divide the paper, holding together the great activity of the hunt. The implied line, that subtle line that is lost and found between objects, starts at the tree that divides the two horses and touches the head and front feet of the foreground dog. There is also a horizontal center implied line used with the dog entering the composition from the left, touching the leg of the horse and then passing to the opposite side of the field. With such an active painting, I felt I had to stabilize some of this action of the painting and prevent it from becoming chaotic; horizontal lines do this.

THE GOLDEN SECTION.

A sound painting is made up of beautiful arrangements of values and color, and what helps in arranging the shapes is a knowledge of proportions. Some areas of the painting are more important than others, obviously, and are more pleasing to the eye. One of these areas, or lines, is called the "golden section."

The golden section has been used by artists, architects, philosophers and mathematicians since antiquity. According to the architect Ernest Flagg, the golden section was used for the plan of much Greek architecture. The Parthenon and other Greek temples, he said, were designed in particular ratios of proportion. The ratio was repeated throughout the building thereby creating a strongly integrated structure.

The golden section is a geometric proportion which Renaissance writers called the divine proportion. It is believed by many of them that a rectangle with sides in this ratio creates a unique beauty.

Let us now see how the golden section can be used to proportion a full sheet of watercolor paper. Using the 30-inch side of the 22 x 30" sheet, we'll multiply it by 0.618, the "golden" ratio, arrived at centuries ago by mathematicians. The number we come up with is 18.54 inches. The watercolor paper is now divided into two rectangles: one 18.54 by 22; the other 11.46 by 22. Well, so much for that. Now we have to find a way to arrive at this proportion in a more practical manner. While it may not be accurate enough to build a rocket for space travel, it is accurate enough for our compositional purposes.

Starting once again with a full sheet of watercolor paper, we divide the 30-inch side in half (15") and then half again (7 1/2") and halve this in the middle of these two pieces (3 3/4" each). This gives us a rectangle of 18 3/4 by 22, which is good enough for our painting. Just remember: half, half and halve it again. After trying this two or three times, you can most likely do it by your eye and won't need the help of a ruler.

If we take a line and divide it into a golden section, we may divide it again and again to get many divisions and sub divisions of the line without ever repeating the same. All divisions have the same ratios to each other and to the whole. It is very worthwhile to consider this and to get it into our subconscious so we may always see it as we "set up" our arrangements of shapes in our painting. This knowledge becomes our servant; it is always there. See *Figure 20* on the following page.

FIGURE 20.

A golden section and its beautiful divisions of space are related to each other and to the entire surface.

1/2 1/2 1/2

GOLDEN SECTION
Center

1/2
1/2
1/2

Center

GOLDEN SECTION

15" 3¾" 7½"

GOLDEN SECTION

GOLDEN SECTION

18¾"

B	A
D	C

The use of golden sections in dividing a painting in 4 parts.

It is the most pleasing division, and in variations, depending on the proportions of the paper, is seen in all good paintings. A and D are the same shape and direction of the painting, giving unity with variety of size and they also repeat the original, or parent, rectangle. C and B are the same size but different shapes. This gives contrast but unity of size.

How can knowing this help you with your compositions? *Figure 21* is a painting I did in the Gloucester woods. It features a well-worn path used by walkers and horseback riders. I wanted to show that it went somewhere, to the trees and beyond. Also, it was an experiment for me to see if these sections really worked. And so, I divided the paper, as I've just described. The tree fell on a golden section line. the horizontal golden section was placed high and ran across the top of the rocks. Of course, I did not draw these in first; I just wanted to break up the paper in these proportions. On this painting everything worked. I was going to add figures when I got home but found that anything I added would destroy a good composition.

FIGURE 21.

FIGURE 22.

In the painting of the marshes of Cape Hedge in Rockport, *Figure 22* (page 32), merely placed the horizon line — the water on the horizontal golden section — and used the other golden section with a gray cloud. I placed the houses in the vertical left golden section, which is the middle line of the houses I used, giving equal distance to both sides of this group. I no longer think of doing this; it just happens.

Figure 23 is a painting that is very complex in its structure. Again, I thought it might be fun to see how far I could go with the composition. The blue jay, my subject, has its head touching and passing through the center line, which is a very powerful position. But the bird itself is completely balanced in a golden section. If there were nothing else on the paper, the bird would balance the white paper. I entered the painting with a small pot in the lower golden section and used the entire small square to place the forward two pots and jug. These are painted with more hard edges than the rest of the

painting, setting up the perspective of the closest foreground of the painting. In order to make the painting feel as if a bird could fly, I used two diagonals: one, the greater, should go from corner to corner; the other, the lesser, should go from corner to a golden section or square.

If you notice, the diagonal forming the bird has help in its strength with other implied diagonals made from lines going to the vase and foliage and the other is the great broken pot leading down to the darks of the leaves. I have to admit when I start drawing, I have a plan but not this involved. As the drawing progresses it gives me the idea of just where these diagonals go and I then, with my trusty eraser, move objects so they fall into these lines. For me, this setting up of the painting is even more exciting than the painting process itself. As you paint you also can move color and value to find implied diagonals, verticals and horizontals. Don't worry about doing this, it will come naturally as you progress with your painting life.

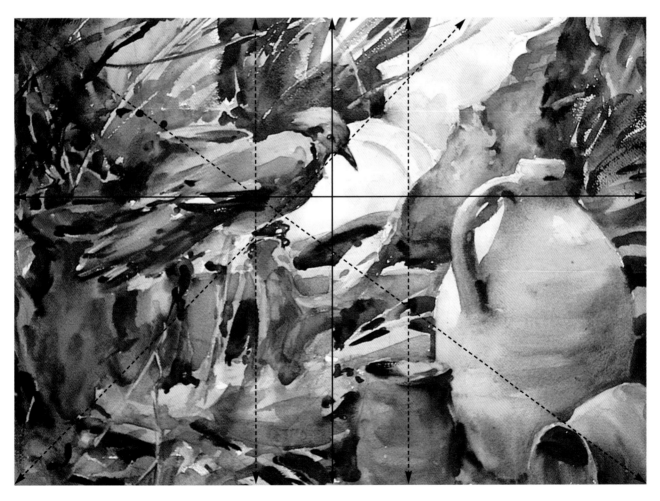

FIGURE 23.

Figure 24 is of a very simple painting. I started with the church in a good area — golden section — and the tree in the foreground in the other golden section. This was painted after an extremely heavy snowfall and the temperature was frigid. I painted this in a hurry, huddled next to a building for warmth.

In the two paintings that I did while in Portugal, I made use of the diagonals to stress the action. *Figure 25* is a study that I did at the scene. The evening that I arrived there was a terrible surf and a ship was in great trouble. All of the able-bodied men of the village manned these small boats to go out and help. I wanted to capture the action and danger that all concerned found themselves in. The large curves in the foreground, the forms that water takes, gives us the feeling of space and leads us into the painting.

Figure 26 is a larger painting. The ship in distress, at the right of the picture, has help in the composition to make it more important by the implied lines on the man's head directly underneath it. Also, the center was found with the front of the

FIGURE 24.

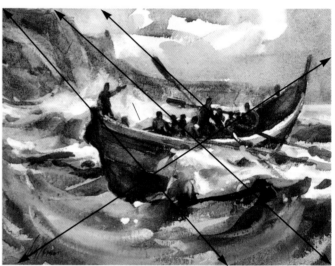

FIGURE 25.

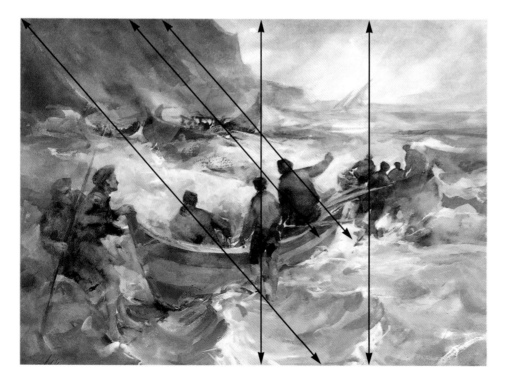

FIGURE 26.

FIGURE 27.

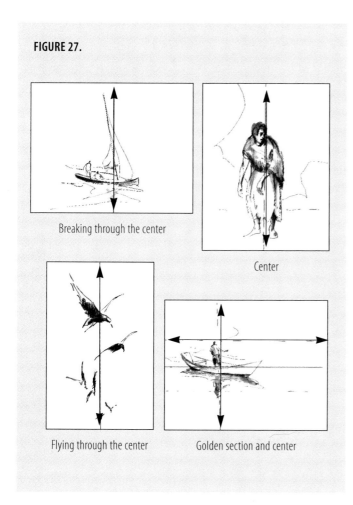

Breaking through the center

Center

Flying through the center

Golden section and center

FIGURE 28.

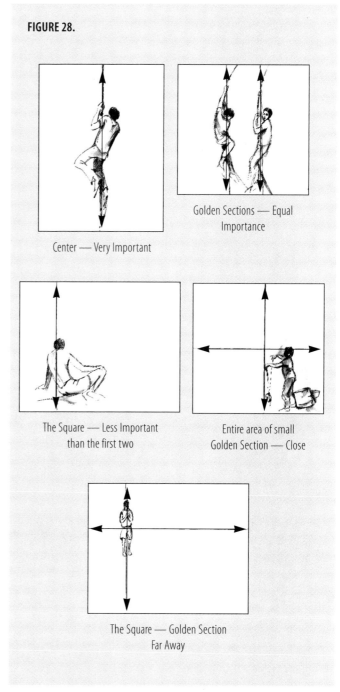

Center — Very Important

Golden Sections — Equal Importance

The Square — Less Important than the first two

Entire area of small Golden Section — Close

The Square — Golden Section Far Away

large boat in the background that's situated directly over the man's head. An arm is reaching out and pointing toward the distressed ship in the distance. It is your composition that really tells you what is happening. Without understanding composition you may place objects and shapes pleasingly but they will never express the drama and thoughts you had to say. Art is emotion in organized form.

One of my first thoughts in placing an object or the subject into a painting is to ask myself how I feel about it. I explain this idea in the sketches that follow (see *Figure 27*).

Use of center. I truly love the subject and so I give it center stage. Where you place the subject on the center line is up to you and up to how you feel about it. Once you place something in the center, you must balance it with other shapes in the painting.

Where we place an object and how large or small we make it tells us of our feelings and expresses the thought we

are trying to give. The diagrams above help to describe this. (see *Figure 28*).

It is only my thoughts and to me they make sense in the importance in position, but these can change when you add color and values. When color or values have great contrast, they express even more.

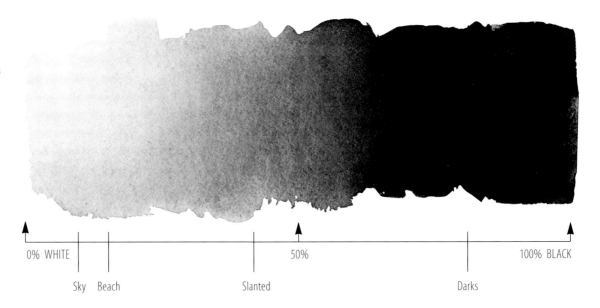

FIGURE 29.

VALUE SCALE:
The value scale is
graduated in easy steps
from white to black.

0% WHITE 50% 100% BLACK

Sky Beach Slanted Darks

VALUES.
Most painters believe values to be the most important part of any painting. No matter how beautiful the colors, how perfectly placed the arrangement with thoughtful proportions, if the painting is weak in values, it will be a mediocre or even poor piece of work. The values are the skeleton of the painting on which color and form are added. Without good values the painting collapses. When a young artist masters the values, he or she is well along the way in the quest to be a recognized painter.

Our world gives us so many nuances of values that they cannot be numbered. If our painting would have all these values it would be a jumble. A limited scale value, therefore, gives the painting strength and validity.

To find the values that will be helpful in your painting, let's start with a scale of 0 to 100, with 0 being white and 100 black. We'll divide this scale with five values, giving us a light, light midtone, middle midtone, dark midtone and dark. On the scale shown in **Figure 29,** I'm using the values we would see in a sunlit beach scene. The sky and the beach would be the lightest values. Objects that are slanted from the light are your next darkest value and planes that are upright and against the the light (uninfluenced by the sun) become our darkest value. So you see, we have here a high major key painting because of the great range of dark to light although we do not go to white or black.

Of course, this value range would change if the figure faced the light but it would still read: white, sky, beach, figure, slanted, all in the value range before we reach 50% with nothing in value from that range to black. This is so because the sky, except for white, or certain colors, is the lightest value; the light then falls on the flat beach, the beach then taking the next value. The figure, although hit with the light, is an upright plane and takes the next lightest value. The darks, and how dark you find them, is your last value to look for. Then we have the darks of even black accents where the light cannot enter. And, of course, we must also consider highlights. Try not to break the value scales of these masses with too many highlights and darks. You must be aware, also, of those days when the sky is darker than the beach or figures. You must always relate the values to each particular day.

Every subject and every day gives us a different value range. That is why the artist must have a very sensitive eye to observe these subtle value ranges. It is also why it is bad to paint a scene too slowly because light is always changing.

The artist must grasp the light in the first half hour. He or she must find the great ranges between the sky and the darks, the light midtones to the light, and the relationship to the other midtones and to the darks. Of greatest importance: how far is the light from the dark? After that, we can paint all day.

We must try to observe all the values nature gives us and then group them together in four or five large value masses. After that, we can then vary them a little with form and detail. But always remember that the values are what make the paint-

ing's shapes. The values are of greatest importance and one of the first things to be considered. After we have the value, then we may add color to it.

One of the first "rules" I learned was white in shadow, because everything in the light is lighter than white in shadow and everything in the dark is darker than white in shadow. So you see, we have a key value to judge others with at the beginning of our painting. That value is white in shadow, which should be that of an object close to us not one in the distance.

I read many years ago about how Paul Cezanne, when painting the model in a sketch group, put his black hat on one side of him and a white handkerchief on the other side. This was to enable him to observe all values next to white and black. It seems, to me, a very wise thing to do.

Values on forms take greater contrasts as they are close to us, and the value ranges on form become less as they recede until finally they become one value. This is perspective in values.

Always remember to consider the value scale in order to express the subject. How light is your light? Are your midtones more to the light or are they closer to the dark? Are you giving the painting a full range? If so, we shall call it a major key painting, black to white, great contrasts; such could suggest the 4th of July, an exciting boat race or a dance. Maybe we feel differently, quiet but happy, high minor keys, midtones very close to the light. Or is it sadness or melancholy, minor key with the midtones close to the darks.

To close out these thoughts on values, I've reproduced two of my paintings; one is a low key interpretation, the other is in a high key.

Figure 30A is a low key painting; very little light. The light midtone is closer to the 50% value than it is to the light. The dark midtones are carrying the importance to the painting. Although dark, the drape and apples are very intense in color. The apple is. as we say, straight out of the tube in its intensity but the apple is slightly warmed and cooled in its form. The drape changes in its color and intensity as it moves from side to opposite side of the picture and becomes almost a blue as it recedes to the left near the large bottle. The old water container changes color from the drape to the cool light of the room and also from the apples and warm source of light. Note how this painting shows the importance of the edge. The side near the foreground apple, although dark in broken line, is sharp, and the other side, as it turns, loses completely in values and color.

This is so the artist or viewer is seeing it and is close to the left side. Notice the loss in interest and edge of the far right apple to that closest to us and to the container. The large apple and container become the subject because color and edge are greatest here, also so is the detail.

Figure 31 is a high key painting. The sky, snow and bushes are closer to the light value than the 50% we see in the darks of the horse. Because the value jump is so great between the landscape and dark horse and rider, they become the subject. Your eye always travels to where the value jump is the greatest.

FIGURE 30.
The importance of the edge. The side near the foreground apple, although dark in broken line, is sharp, and the other side, as it turns, loses completely in values and color.

FIGURE 31.

Mood

ow that we've discussed certain basic effects of light, let's take a minute to talk about the elements of a painting that are most closely related to these basic light effects: the key of the picture, the character of edges, and the use of various washes.

CALEB'S LANE. 22 X 30"

In this picture, I wanted to emphasize the cold, blustery nature of a Rockport winter. I tried to suggest the force of the wind by angling the foreground saplings. They move diagonally, paralleling the shape of the large, windblown snowdrifts. These saplings didn't angle as forcefully on the spot; I simply seized on an aspect of their movement and exaggerated it for expressive effect. Notice that the children are tied in with the trees and the shadows of the snow. Their clothing is also dull in color so they become part of the whole scene. They're not my subject. Although I finished the picture in the studio, I began it on the spot. It's essential to feel cold in order to paint it convincingly.

KEY. One of the major ways light creates mood in a painting is through key. How, for example, will the lights and darks be distributed in a picture? Which will predominate? And how will the key relate to the character of the subject?

You may find key easier to understand if you compare the basic black-and-white value scale (*Figure 29* on page 36) to the keyboard of a piano. The 50% value is at the center of the scale, what we'll call middle C in our piano analogy. In any given picture, a certain amount of color will be low in value (below middle C). Such color is like the deep, sonorous notes of the piano. A certain amount of color will also be high in value (above middle C). Such color is like the brilliant notes of the piano's upper register.

The values in a picture actually affect our eyes very much like musical notes affect our ears. If there is a predominance of darks in a picture, for example, the picture is said to be low in key. And the darks usually create a brooding, sober, dramatic feeling — just as would a piece of music similarly full of deep notes. If there are a lot of brilliant whites and light grays in a picture, the picture is said to be high in key. The effect on the viewer is usually a happy one, just like the effect of a piece of music played in the piano's bright upper register.

What is uninteresting, both in painting and music, is a composition in which the notes all cluster around middle C or in which there are exactly as many low notes as high ones. There's no dominant idea in such work. And looking at it is the visual equivalent of listening to idle chatter at a party, where pleasantries are passed without anything really being said.

Directing the Eye through Values. You can direct the viewer's eye by the way you distribute your darks, lights, and midtones. If the darks and midtones cluster below middle C, with only a few lights far above middle C or 50% mark, then the greatest interval is between the midtones and the lights. The result is that the lights pop. The viewer sees them first. I've illustrated this effect in *Figure 32.* Because the sky, trees, ground, and out-of-light darks are all close in value, you are therefore struck by the brilliant white of the sunlit house.

If on the other hand, there are only a few deep accents in your picture, while the lights and midtones are all clustered above middle C, then the greatest interval is between the midtones and the darks — and so the darks pop. In *Figure 33* (page 40), the dark ground, roof, and trees stand out against the light, close values of the houses and the sky.

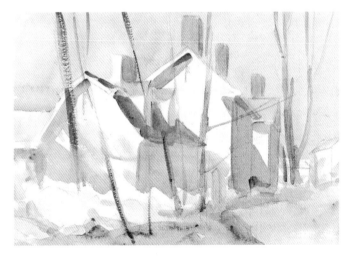

FIGURE 32. On a sunny day, the midtones and darks are close together, while whites are high on the scale — you therefore see the whites first.

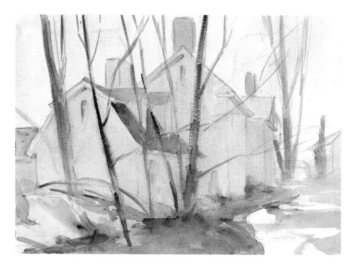

FIGURE 33. On a gray day, the lights and midtones are clustered together, while the darks are low on the scale — you therefore see the darks first.

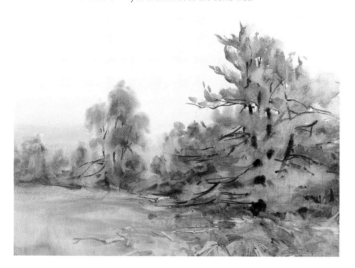

FIGURE 34. The day is beginning to clear. An early morning rain has touched the earth and as the sun filters through the clouds, the world becomes very light, created by the sky and all flat planes.

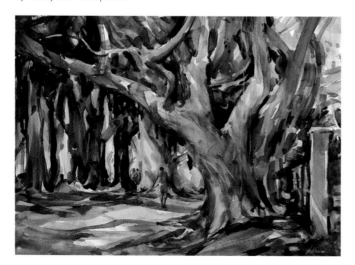

FIGURE 35. Sharp value contrasts add to the visual effect of sun and shadows on these great floral trees.

Expressive Use of Key. As a further example of the expressive use of key, look at *Figures 34 and 35.* The field in *Figure 34* is bathed in light. Although the field rolls in and out of the light, the sun creeps into all the darks, making it light and airy. Using our piano analogy, we can see that the midtones and lights are all above middle C, while the dark notes are just below middle C. The lack of contrast accentuates the peacefulness of the scene.

In *Figure 35,* on the other hand, there is sharp value contrasts. The shadows are a fairly dark color to begin with. In addition, we are looking into the light of the sunlit street that's farther away from us. As a result, the midtones and darks are all below middle C, with just a few warm lights high in the register. They're exciting, like the brilliant high notes on a piano. The strong value contrasts gives life to the painting, just as the closeness of values in *Figure 34* creates a more serene mood.

EDGES. Key is one of the ways that light creates mood in a painting. Light also affects the edges of objects and these edges can, in themselves, be important expressive elements. In a rapidly painted sketch such as *Figure 36,* for example, you can see great variety in the way the edges are handled.

1. Hard Edge. A hard edge *(Figure 36a)* suggests strength and attracts the viewer's attention. Where the sun hits the topmost flower, I emphasize the light area by bringing it sharply against a dark background leaf.

2. Soft Edge. I don't want to attract attention to these subsidiary areas, so I merge one with the other along a soft, hardly definable edge *(Figure 36b).*

3. Rough Brush. Using a quick, brusque movement of the brush, I am able to break up edges. The rough-brush stroke *(Figure 36c)* stands between the hard and soft edge, weaker than one, stronger than the other. Although a "rough-brush" mark looks somewhat similar to what most people call a "drybrush" mark, I'm giving it a different name because I use it for a different purpose. In addition, a drybrush mark is, of course, made with a dry brush; the rough-brush stroke uses pigment and water. The most noticeable thing about drybrush marks is that they can cover a multitude of sins. When you make a mistake, it's easy to cover up with drybrush. A rough brush

FIGURE 36.

stroke, on the other hand, is applied vigorously, with strength but reserve, to a part of the painting and is designed to tell us about the character of an object through the nature of its edge.

4. The Lost-and-Found Edge. Where two edges meet it is hard in some places and soft — even lost — in others. These hard and soft marks *(Figure 36d)* are typical of areas that move in and out of the light. We need this variety. If all the edges in our picture were either hard or soft, it would look too stiff — or too "pretty."

5. Broken Edge. Unlike the lost-and-found edge, the value contrasts along a broken edge *(Figure 36e)* are always clearly seen. The light and dark accents cut into and across one

another, breaking the edge and adding extra interest to it. If I wanted to suggest the lushness and warmth, I would, in addition to the deep color, warm up the greens also. On the other hand, if I wanted to paint the strength of flowers, the edges would be hard and, in some areas of the painting, broken so the whole painting would feel of this strength. In order to show how tall the flowers can grow, perhaps our imagination could be used if we could see the sky through them.

6. Scratches. Stems *(not shown)* are suggested by quick marks, made in the wet wash with the end of the brush. The lines are broken so that, once again, they have the elusive look of nature.

EXPRESSION AND EXAGGERATION. We

give expressiveness to a painting through our use of key, edges, and color. Those are the important things. Yet most painters, including myself, are always in danger of getting too involved in the details of the subject. Ed Whitney — well-known artist, teacher, and author — always said that when you bought a coat, you looked for the fit not for the buttonholes. So don't worry about the buttonholes; instead, paint what you feel about nature.

Your feeling for a subject shows in your exaggerations. If I were painting a boat race, for example, I'd express my excitement by exaggerating the color. And the exaggeration would work, as long as it was seen throughout the picture. Each painting should be consistent within itself, so that if you ripped a number of them into small pieces, you could tell — just from the nature of the colors and the strokes — which pieces belong to which work.

A WORD ABOUT WASHES. As we've seen,

nature's color is full of variety, but how can we get that feeling into our painting? Not, I think, by working as I did in art school: I can still remember classroom exercises in which I had to fill square after square with color, in an effort to get a perfectly graded wash. The more I see of nature, the more I dislike such "beautifully painted" washes. They look too much like paint to me; when I see them at a show, I feel like wetting my finger and messing them up! Anything to vary the wash and give it the look that I think more accurately suggests color, atmosphere, and light. Better the expressive wash, than a mechanically perfect one!

Lighter, Brighter; Darker, Duller. Mae Bennett-Brown, the fine painter of flowers, had a saying: "lighter, brighter; darker, duller." She meant that every time you touch a wash, you dull it. The white paper is the cleanest and brightest light of all. The first wash sits on the surface of the paper and is very luminous. A second wash, glazed over the first, naturally muddies and dulls the color. A third wash is duller still. And so on: lighter, brighter; darker, duller.

Light is the life of the painting. And to guarantee bright, luminous lights, the washes describing them should be lively, bright, spontaneous and unworked. Lighter, brighter. When working the first washes, I usually paint the entire object (1) in light, (2) moving from the light, and (3) turning from the light. I pull the moving and turning-from-the-light wash right into what will eventually be the out-of-light part of the object.

Instead of being brilliant and vital, the out-of-light and shadow areas should be places of rest; places to take it easy. I therefore glaze the darker washes over my first wash — now bone dry — always leaving the in-light part of the wash alone. Mess up the in-light wash and you might as well throw the paper away. In general, these second washes are (1) darker, (2) cooler, and (3) heavier in paint quality. Darker, duller. I glaze with a light touch in order to avoid lifting the first wash. It's important that you feel the lighter, brighter color through the darker glazes; that gives the darks luminosity and life. It also relates the light and out-of-light areas. All students recognize the importance of such a relationship, particularly if you've been taught to handle the light and dark sides of an object as if they were separate and distinct areas. More often than not, the object ends up looking as if it were painted two different colors. *REMEMBER: light should unify objects — not split them apart.*

The Practical Approach to Washes. My belief in glazes and untouched washes is a result of my feeling about light. But there are also some very practical reasons why such a logical, step-by-step method is a good one to use. To begin with, most people find it easy to concentrate on a few ideas at a time, and the bigger the idea, the more attention you can give to it. So in the first wash, I think "light" and don't worry about the darks.

It's also difficult technically to do everything in one wash: you can't control your edges. Place a wet dark wash near a wet light one, for example, and the color bleeds from area to area. You touch the edge, trying to contain the washes, but the more you touch, the more you damage the paper. I want to avoid this nervous and frustrated sort of picking.

Working in a series of washes also gives you better control of your color. As you'll see in the following demonstrations, you can vary the quality and quantity of pigment, creating a variety of transparent and semi-transparent effects, a variety that parallels the kind of complex visual sensation you have when you look at nature.

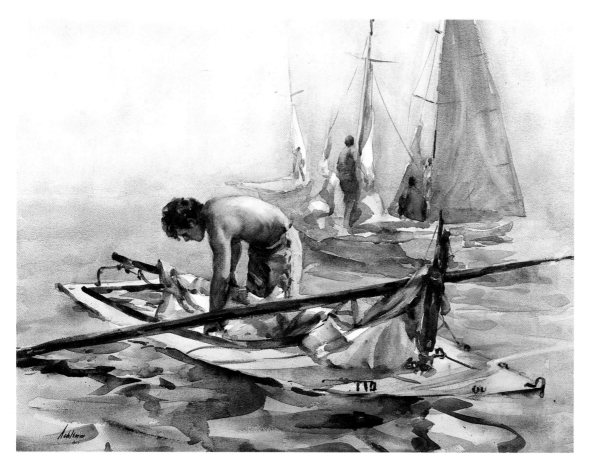

FIGURE 37.

A SUDDEN STORM.
We are able to travel far
into the distance with
the use of the standing
figures next to the white
sails. Back, back we go.
This painting was done
from sketches and
photos after a sudden,
severe storm in Rockport
Harbor. I painted it in
quiet colors and vertical
dominance to show that
all was safe.

There's yet another reason why I prefer to work wash over wash. It's a logical procedure. And using it, you don't get bogged down in technical questions, questions far removed from the painting process. As you work, you think about only two things: what is the subject and what is the light doing to it? You don't worry about tricks: should I sponge, scrape, or splatter? You look — and paint!

AN EXAMPLE. I'll end this discussion by quickly looking at a painting that uses the sky for an expressive purpose. In *Figure 37*, I wanted to emphasize that the storm had ended. The sky was painted first with a wash of Cadmium Red (very light) and before it dried, I painted in the pearly blue grays of the atmosphere. This caused the color to break up just slightly and gave a feeling of light and lifting fog. Notice how the color changes from the left to the right. There is still some rain in the right and the color is greater and more intense in the close water and quickly receding and turning into the sky in the distance. We cannot see where one begins and ends because of the moisture in the air. The young sailor had made every effort to save his sailboat but to no avail. The quiet color and vertical dominances show us that it is all safe now.

The sky breaks into the horizon, softening it and giving you the feeling that you could sail over it and out to sea.

Procedure

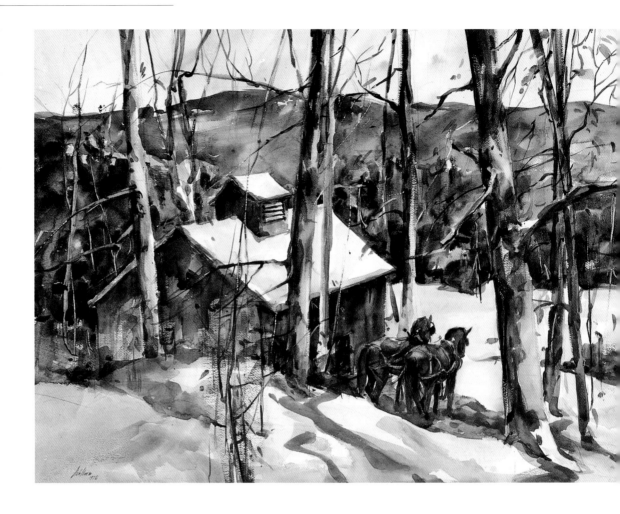

\mathcal{I}n order to make my later, more-detailed demonstrations understandable. I'm going to discuss in the following demonstration the practical application of the ideas expressed in Chapters 3 and 4.

JEFFERSONVILLE WINTER. 22 X 30"

This is a primarily linear design, a pattern set by the long lines of the upright trees. The foreground shadows repeat the linear theme. They also lead you into the picture and, by moving over the snow, give you a sense of the lay of the land. All with a minimum of effort on the part of the painter.

DECISIONS BEFORE YOU PAINT. Certain

decisions have to be made even before you start to paint. For example: What kind of day is it? Where is the sun? "Over there," many students say, running their hand across the left-hand side of their paper. They don't realize that you have to pinpoint the sun in the sky. Is it to the left or right? Is it high or low? In front of you or behind you? Each shift in position changes the character of the subject. That's why watercolorists learn to work quickly outdoors.

The light determines the quality of the edges, the vibrancy of the color, and the contrast between values (the key of the

picture). You have to determine your theme, the kind of mass and line that corresponds to the theme and even the paper that best fits the particular subject. I'll discuss these questions in each of the following demonstrations, for I never start to paint until each has been answered in my mind. There's danger in watercolor when you only half-know and then try to correct while you paint. Know first, and the medium will work for you.

In this case, I'm painting horses on a gray, very cold day. Snow is in the air, softening all the edges. I work hard to draw the horses correctly but my real subject is the quiet mood of the day. I paint what I feel, not just what I see.

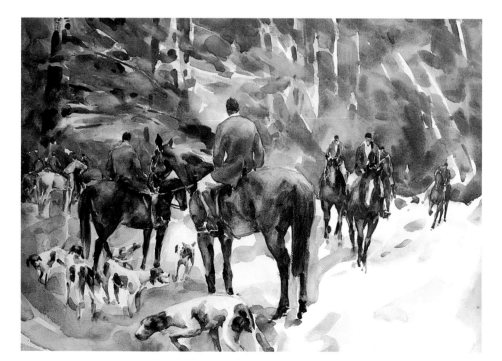

A THANKSGIVING HUNT.

The foreground snow is the white paper. I've used it throughout this painting creating the effect of snow on the trees and also what little there is on the dogs and the figures. Try not to touch the white paper too much; always keep it clean. To find the white patterns, I quickly painted all the white in shadow areas first. I then started painting the foreground horse and rider; next the rider in the distance. This was to be sure to get the great space in this snow-filled rest stop of our hunt.

1 I first paint the warm sky, preparing the area by wetting it in a hit-or-miss fashion; the wet paper gives me a better control of the wash. The sky color reflects down on the upright planes of the snow. This makes more sense, I think, than the old watercolor practice of unifying a picture by throwing a lot of earth color into the heavens. Pretend, instead, that you're the sun and sky, and gently touch the planes of the earth with suggestions of sun and sky color.

Notice the difference in the snow areas to the left of the foreground horse. At its hooves, the horizontal plane of snow is touched with light, warm color. The sky directly affects it. The light has less of an effect on the slanted snowbank to the left of the horse's head, however; it turns from the light and is therefore darker and cooler.

As you can see, the background wash contains a variety of textures and colors. You don't find many flat tones in nature so I try to get away from the feeling of paint by letting the pigments do beautiful things by themselves. Water is the key. Remember: it's waterCOLOR when we discuss light; but WATERcolor when we apply our washes. Too much pigment makes a wash opaque and dead. Water breaks up the washes and emphasizes the paper, our most precious commodity.

Pack as much information into your first wash as you can, subject, of course, to the technical limitations that we've already discussed. I paint the areas inch by inch, color change by color change — discovering the subject as I make a more careful study of it. The more I look, the more I see. I try to keep things soft in these first washes, adding dark accents and hard edges toward the end of the painting process.

2 I glaze over the background with dark washes that represent trees and branches. I let the sky show here and there. Elsewhere, it's felt through the darker washes, so you always feel the sky is affecting the mass. I couldn't get this effect by painting the background in one process; I need both the first wash and the later glazes.

I have great variety within the background mass: rough brushstrokes, wet-in-wet areas, hard edges, soft edges, even a few scratched lines. I keep my statements simple, not worrying about individual trees. If I start to worry about them, I'll forget why I'm painting the picture in the first place. I also let my washes work for me. Notice, for example, how one wash does many things: pulled over an out-of-light area, for example, it both softens edges and dulls color, thus making the in-light areas seem all the more sharp and clean.

Notice also that I don't finish the picture piece by piece. I work all over the paper, as would an oil painter.

REMEMBER: *We're painters first — painters who just happen to use watercolor!*

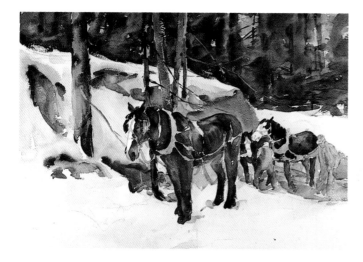

3 As in the previous steps, I use the first wash to model the foreground horse. While the wash is wet, I can't put in a lot of dark accents so I leave them for the later steps. I study the horse, putting in the color changes where I see them. Notice, for example, how the warm light of the sky touches the back of the horse exactly as it reflects down onto the snow. There's more blue (cooler color) on the side of the horse as it turns from the light.

I lighten parts of the horse by adding water and color. Students tend to lighten areas by adding water alone. But nothing damages a design more than having the lights all go to white. You end up with a bunch of disjointed spots. Lithographers know all about the problem; working in black and white, they soon become masters of the midtone. They carefully keep most of their highlights low in value so that the important ones stand out.

4 I glaze over the snow, defining the different planes and introducing a lot of rhythmic lines in the foreground. They suggest the effect of the wind on the snow. Touches of cool color in the out-of-light areas add excitement to the foreground. Now that the wash is dry, I return to the foreground horse, adding dark, no-light accents and further defining planes by additional glazes. The varied washes give the horse character and suggest different surface qualities. Yet because the preliminary wash is felt beneath the glazes, the horse holds together as a unit. It doesn't become a series of disjointed spots.

I always stop work on a watercolor just before it's finished. I rest, evaluate, and think about corrections. The important question is: Can the corrections be made without ruining the watercolor? You should feel the paper coming through your washes. But if you overwork the washes, you lose the feeling both of the paper and of the light. So, if you don't know what to do, stop! But if you've figured out a problem, push ahead and see what happens. Never simply throw the paper away. You'll just hit the same problem again someday and, again, you won't know what to do. Each painting — even a failure — is a learning experience; it prepares you for the next attempt.

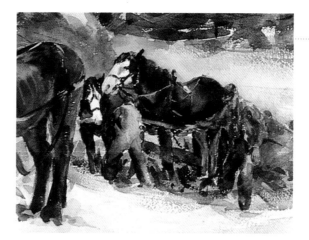

DETAIL 1. Here we can see in detail the action of the day and its happenings.

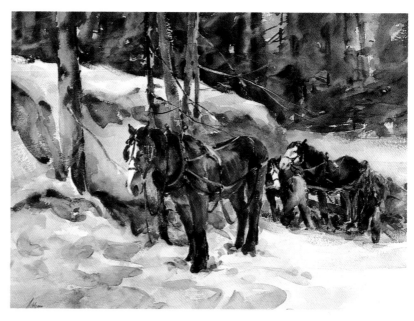

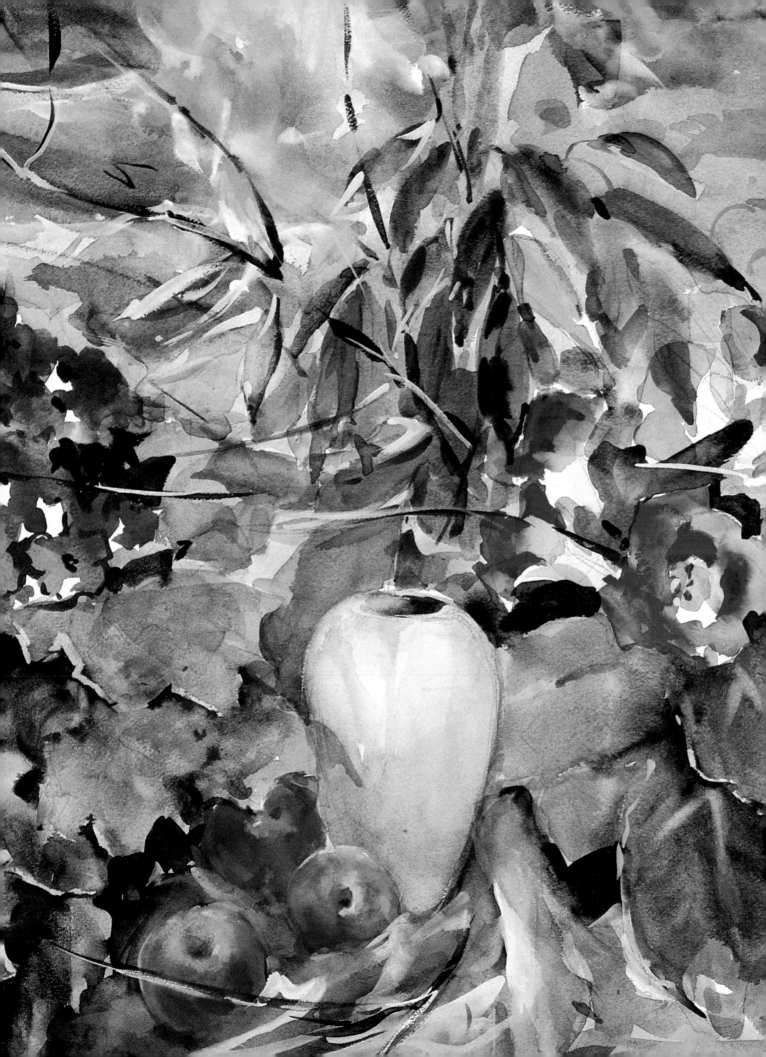

Demonstrations

Demonstrations

We've discussed materials, color, and the way my ideas about light affects my washes. The demonstrations that follow look more specifically at all these questions. The exact colors I use and their proportions in each mix always change from day to day, depending on the quality of the light and, just as importantly, on how I happen to feel at the time. If, for example, there were one and only one way to mix the color of white in shadow, or a summer day, or the Atlantic Ocean, painting would merely be the application of mechanical formulas. You might as well let a computer paint your picture. In the following demonstrations, then, I'm not interested in giving you color recipes. Instead, I'll try to suggest ways of working which will make you (1) look more closely at nature and (2) think more before you paint.

You'll notice that in each demonstration the light changes, but my painting procedure remains the same. That's the rule of the game. Some people dislike rules; but I find that a particular way of working gives me an extra freedom. Rather than worry about technique, I can concentrate on the more important problem of interpretation.

This procedure works for me, but may not work for you. And you'll certainly want to change and modify my ideas in order to make them fit your own needs and purposes. I'll be happy if the following demonstrations start you thinking about light and form. I'll be unhappy if they only show you how to paint the subjects I like for that's of little help when you decide to paint the subjects *you* like.

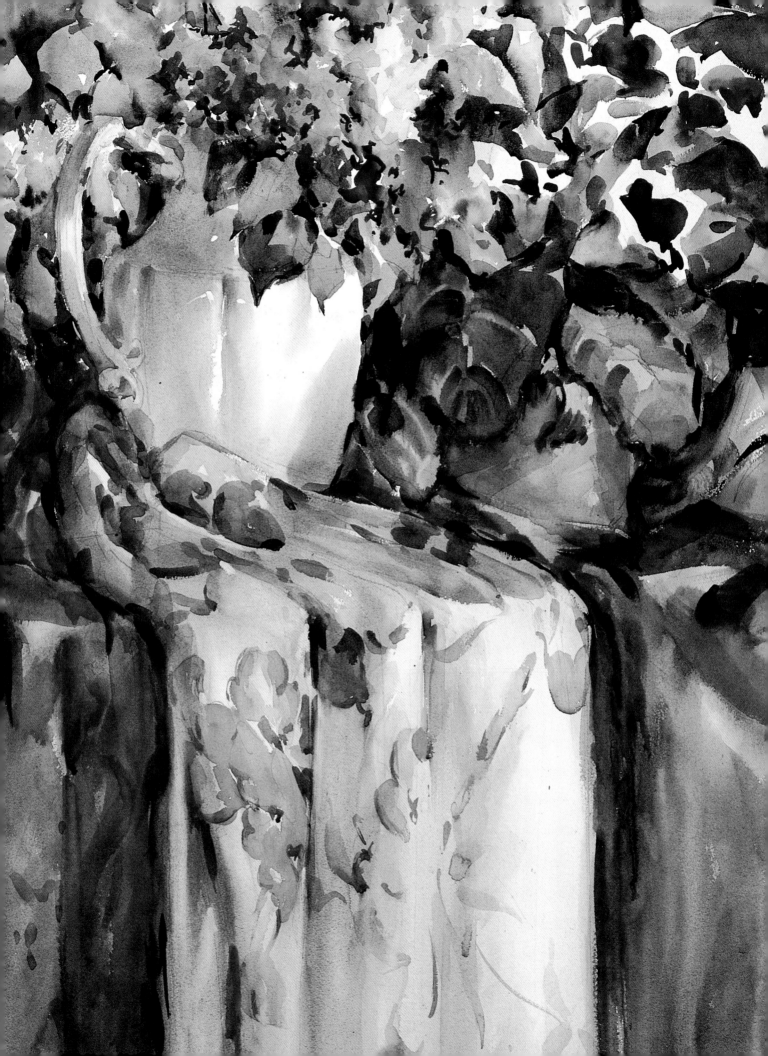

THE WHITE PITCHER. *(Figure 38)*

Springtime and the lilacs were out. I felt so good, happy; this is a wonderful time of the year. I placed the white pitcher high in the composition because I feel that to look up is a more joyous feeling than to look down. Very often, when doing a street scene, I will place the lights high on the paper.

Light on Curved Surfaces

THE PUMPKINS WITH CHESS PIECES.

By losing the out-of-light areas and forcing the lights in the long leaves, we send the pumpkins into the middle ground of the painting with the chess pieces coming forward. The light is very close and the shadows, deep into the painting, have become dark and almost colorless.

Demonstration

1

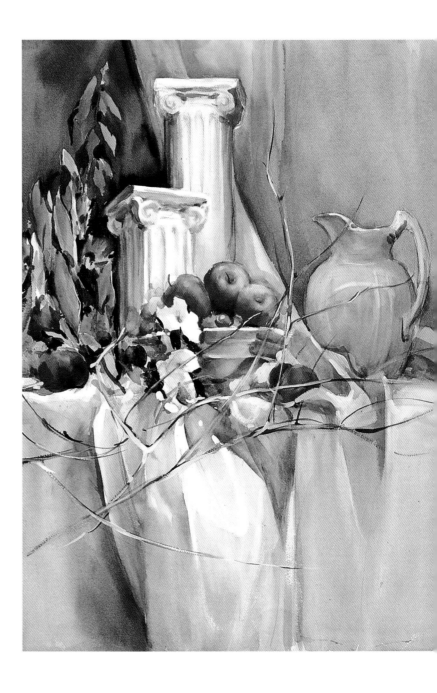

In the following demonstration, the columns and the white pitcher are both interesting, but the bowl of fruit is the real focal point. I've aimed the spotlight directly at the focal point; it is this light, of course, that tells you where to look first. It defines the subject. This is really a teaching demonstration; I'm less excited by the subject itself than by what it shows you about the effect of light on rounded surfaces.

LIGHT. I usually light my still lifes with a hundred-watt bulb in a standard photographer's lamp. In the following demonstration, the eye naturally follows the path of light through the picture, moving from the right side — closest to the light — to the left side. The pattern of light moves from a light to a dark area, as well as from a warm area (nearest the light) to a cool one (the shadows on the right-hand side). Because of the nearness of the light, we get fairly rapid changes in color and value. The light, dull yellow drape, lit by the warm bulb, also makes the picture have a high key, warm feeling. Notice that sharp edges occur in the foreground, where the light and dark contrasts are most pronounced. However, the edges soften rapidly as the objects recede from the light.

KEY. This still life is in a high major key with most of the midtone above the middle C range. I am interested in the warm light colors of the subject. Painting all the variations of yellows and whites is a real challenge.

PAPER. The painting is done on a full sheet of Waterford 140-lb cold press watercolor paper. The paper sponges clean very easily, making it possible for me to correct the washes.

PLANNING THE COMPOSITION. There's one great advantage to a still life: unlike nature, it can be conveniently arranged and rearranged in the studio. Since I'm interested in light and in the way it falls on objects — rather than in the objects themselves — I always use a spotlight while arranging a still life. I can later experiment by moving the light closer and farther away. I place the objects carefully and shape the folds of the cloth so they form maplike "directionals" leading the viewer into the design. I curve and break these lines so that they're interesting to look at; I don't want to zip the viewer abruptly in and out of the composition.

Changes in lighting can radically alter the feeling of a still life. In *Figure 38* (page 50), or example, the white pitcher is lit with a light coming from the left and casts gentle shadows from the leaves on its form, giving lovely shapes of cool grays and warm whites. The light filters through the flowers and leaves and shows the forms of the flowing drape. I find this lighting very sensitive. It is placed back from the still life so that the contrast of shadows on the leaves are not too strong. This enables the colors of warm and cool greens to show up best.

PRELIMINARY SKETCHES. I vary the design by the strong horizontal of the table top and the flat surface of the fruit dish. Then curves forming directionals are added to create excitement to the arrangement.

The hardest part of the drawing is always the placement of objects on the paper so that they're varied in shape and exciting to look at. The pieces of white drapery gave me the most trouble. A watercolor is always enhanced by the use of white paper; white areas are our most precious commodity. However, if these shapes are too small or unplanned, they might as well be left out altogether.

Once the drawing is complete, I erase the pencil lines in the in-light areas. The lead pencil line in this wash is distracting and destroys the feeling of light. In the out-of-light areas, such pencil lines aren't as much of a problem. You can't see them. In fact, I take my pencil and darken some lines in these areas to remind myself where I plan to place important accents.

1 & 2 The complete drawing should lay in all basic forms of the composition. Remember that a painter thinks in terms of color and value rather than line. You won't know what's really important in a picture until you've covered most of the paper with color. However, never slight your preliminary drawing. Always give it that extra bit of consideration. Be sure of yourself, never "approximate," and the painting process will be all that much easier

I started the painting with the white pitcher trying to capture all its beautiful form with the first washes, doing everything while it is wet. I then paint all of the white in shadow areas, searching for all their forms as they move and turn away from the light. This is a value most beginners paint too light because they are judging it against white paper; any value against white paper will appear darker than it really is. Remember, white in shadow close up hovers around the fifty percent gray on the value scale. With this knowledge we then can add cool color to it and warm reflected lights.

The warm reflected lights must be dropped into the cool before it dries. These colors will then break up, giving you vibration. You will see both colors but the values will be the same. Without this vibration there would not be a feeling of light. If you do this when it dries, it will be unsuccessful and the values will darken and the color would lose its life.

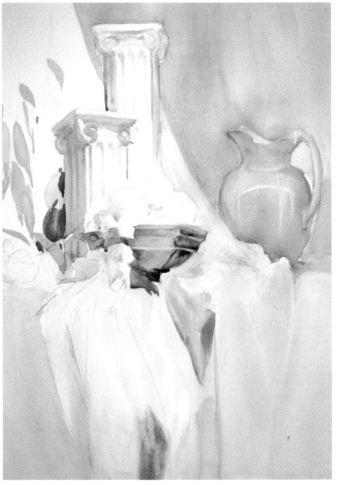

3 Now I add the other lights, making the color feel that it comes close to us and then recedes away and finally into the background. As you do this, even though the drape is in the light, we must drop clean cools into it as the planes change and recede. This vibration gives not just light into the background but also gives a feeling of air. Always drop these colors in when wet. When the color is warm, add cools; when cool, add warms. But you must think of what you are doing and then do it as simply as possible. The lights must always be very clean.

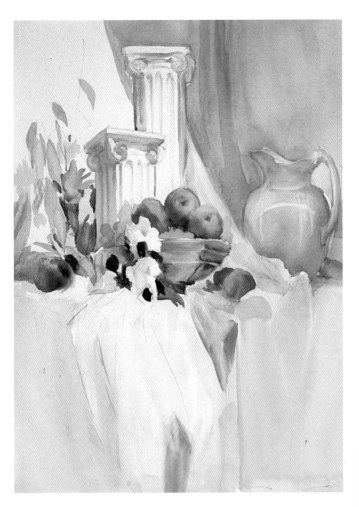

4 Once the light is painted in all its forms, I then start with the darks and the modeling of further forms. I really go after the space in the painting as well as the darks. You will notice the background; I did this first. How far can we recede in the painting? Notice the light value and color were painted first. The value was down in the value scale but because it was warm a feeling of light and air penetrated it. Then, while it was wet, I painted the darks into it. These darks are cool and around the objects in front of the drape (the leaves, columns and yellow drape). As soon as this was painted I then brushed these washes into the warmer, lighter dark with soft edges. This is refraction, the stepping back and forth into space. Without this step, the painting would become flat — no light, no air, no space. Refraction always is how the light affects the edge. The light columns have for an instant blocked the light and then we are able to move into it.

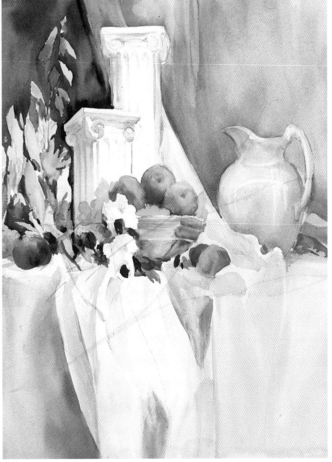

5 In this step, I did the same thing to a lesser degree around the columns, pitcher and the separating of one drape against another. The painters of the past call this step "refraction"; the moderns call it the "passage through."

Finally, I painted the shadow of the white into the cool darks on the left. And this was the closest area to me. Now we start at this shadow and pass through all areas of our painting.

6 *The Finished Painting.* I added the twigs to this still life because I hate being in the house; I love the landscape. With these tender twigs I was able to get a feeling of life into this work as well as light, air and space. The twigs also set up a greater picture plane as they come in front of the drape. I had to use a little body color on this painting to give it light and so I used Chinese White mixed with Cobalt Blue to tell of the cool light that the sky gives and could touch all top planes. I added it also to the sharpness of the edges of the white drape in the foreground to make it more important than all others.

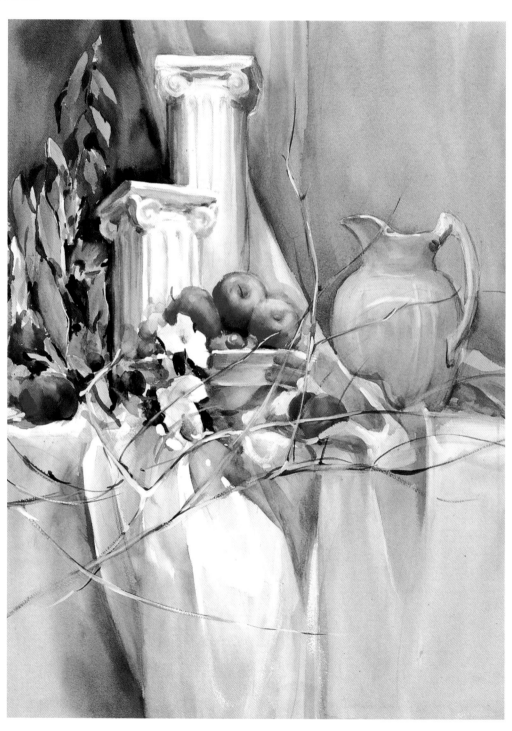

DETAIL 1. On this closeup, although unfinished, you can see the handling of the edges and the modeling of forms.

DETAIL 2. The leaves, flowers and the apples in the back are shapes suggesting what they are, using warm and cool color and value shapes.

DETAIL 3. The details of the apples and flowers are painted realistically and with great importance.

DETAIL 4. Detail two shows the subtle edges of refraction. See how they are lost and found on the columns; also, the reflected light edges, creating deep space, can be seen now more clearly.

THE END OF DAY IN YOSEMITE.

Nature, too, puts on a wonderful light show when the last of the sun's light plays on all its timeless, massive forms. I placed the flying swans low in this painting to express the height. Please notice the pure blue light from the sky on the foreground rocks. This very pure color allows us the closeness of our landscape and then color loses or becomes less intense as we move farther into our landscape. Purity of color comes forward, the blues are more intense than the orange cliffs. With the purity of this colored light, we are able now to move back and forth in space, air and light.

Light on Angular Surfaces

ROCKY NECK, GLOUCESTER.

The afternoon light, late on a warm summer day, casts shadows diagonally across this old waterfront. So many angles out of light with reflected lights then bouncing up into them. This is easily seen on the orange dory.

Demonstration

 ow that we have studied curved shapes indoors, let's go outdoors

and see how sunlight affects angular, architectural forms.

LIGHT. In the still life, the spotlight was close and very strong. This time, let us study the sunny fall day. On such a day, as we move into the picture plane, the light becomes a little diffused. We do this with background edges; because of this slight haze, they become soft. To get these edges and to keep the yellow oranges and reds of our color clean, I used a lot of water in the washes. Into these washes, before they became dry, I added marks into them suggesting forms turning in and out of the light. I use more paint on the brush and less water at this time so the mark holds its shape, but because it is wet, the edges blend and are soft.

KEY. This is a happy day — painted in a major key. The lights and midtones are far apart. The midtones around middle C. There are only a few real darks. I don't want a lot of big value jumps; they'd make the picture too busy, too exciting. I don't feel that kind of excitement on a fall day. It's like playing a piano with a tender touch, not thumping the keys wildly. Autumn calls for expressive exaggeration in color.

PAPER. The painting was done on Waterford 140-lb cold press paper. It's a medium paper, not too hard or soft, and takes good washes.

PLANNING THE COMPOSITION. In the preliminary drawing, I emphasize the vertical character of the New England houses; that uprightness symbolizes for me the propriety and dignity of the people. I echo the vertical movement in the lines of the tall nearby trees. I use these trees much as I used the folds of cloth in our first demonstration, to lead your eye into the picture, while the in-light parts of the houses (near the eaves) pull your eye up into the center.

The trees are arranged vertically and move us into the painting and also lead us subtly to the house. They also add more vertical strength to the house, making it stately.

The challenge of the painting is to take the viewer over the lawn, to the house and down into the sunlit street.

1　*The Drawing.* Before I begin this very important step, I try to quiet myself, leaving all the world behind and to become part of the landscape. Only in this quiet mode can creativity begin for me. It is the great white house I want to tell about: Where is it on the paper? How do I get to it? Perhaps across the lawn. I will place it large enough to dominate the painting and yet low enough to give room for the sky and the trees that reach high into it. And now, after I have reached the house, where do I want to go? Far into the street. How much of an area will I give to this? Perhaps a square. No! I'll put the foreground tree on the square and the side of the house on a golden section line. Good! Perhaps the other tree near the front of the house should take another golden section. Now, at least, I have a little organization. Whatever happens as I paint, the scene will be the values and colors and the patterns they create to express this house on a special fall day.

2　Now it is my feeling that the sky is the thing to work for first. Whatever is in the earth — no matter the value, color or form — it is touched by the light of that one day. And so I'll start with the underside of the clouds, mixing a near neutral gray with Cobalt Blue, Cadmium Red and Yellow Ochre, three primary colors. As I put this on, I am very careful of going around the house and foreground tree, then I move the brush quickly over the paper to fill in a bit more of the wash. My thoughts are not of gray paint but air and light. At this time, I also bring the color down to touch the large foreground tree. I add more color to this wash on the road on the lower left to bring the road closer to me.

3 I then add the blue to this wash in the sky, finding the hazy clouds of this fall day. This is made of Cobalt Blue and Cerulean Blue mixtures. I have to make sure that all edges are soft. I begin to paint the house; remember, a white house in the light is always lighter than the sky and on the shadow side is darker than the sky. White in shadow up close is about a fifty percent difference between black and white. This house is set back from us so the value would not be that great but close to it. Then, while the wash is wet, I change the color of the side of the building by bringing in some blue from the sky. This color becomes lighter than the cast shadow but still stays in the out-of-the-light value range; this helps to give me form. Where the house on the right comes in front of the L-shaped wing (of the house), I darken this L shape as less light is permitted to enter. When you do this, quickly soften edges as the wash moves away from you (this is refraction of the edge or setting up the space between these two picture planes). Notice how very dark the shadow is on the fence and now it picks up some warm reflected light. I have begun now to place color on the painting: The colors of each object and shape as they are in the light and their space in the picture plane. As I paint each color, let us say the roof, I first paint it the orange-brown color that it is. Before it dries, I drop in the color of the light from the sun, perhaps Yellow Ochre, and let it mix by itself. Then I drop in the cool color from the sky — not as much as the sun. This is also done when it is wet. Don't try to mix these colors, just drop them in with a lot of water, the paint will mix itself. This is vibration, the warms and cools affecting local color and value. The last step, I "break" the roof slightly in the direction that the light is coming from. This puts it in its space and not merely "painted on." This is refraction again. Refer to the detail on page 66.

As I painted the lawn, all I thought about was: it is green, it has form and goes away from me. Also the sun color has to be added to this green the same way as the roof and the cool sky reflecting down into it.

4 I now start the trees, thinking only of shapes with their values and colored light added. Where are they in the picture plane and how do they work with my subject, the house? Here, it is obvious that the golden section is where the house is the whitest, and that is only because the darkest dark is next to it. My house at this point is now my subject. Your subject is almost always where the darkest dark and lightest light come together. You will notice that the shadow on the white fence is darker in shadow than the grass. Everything in the light is lighter than white in shadow and everything in the dark is darker than white in shadow.

DETAIL 1. This detail shows the brush strokes that were used to establish the trees as a dominating element.

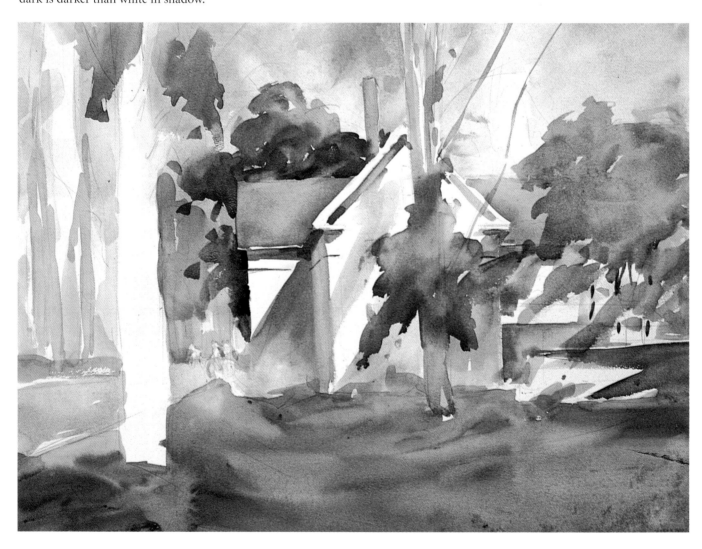

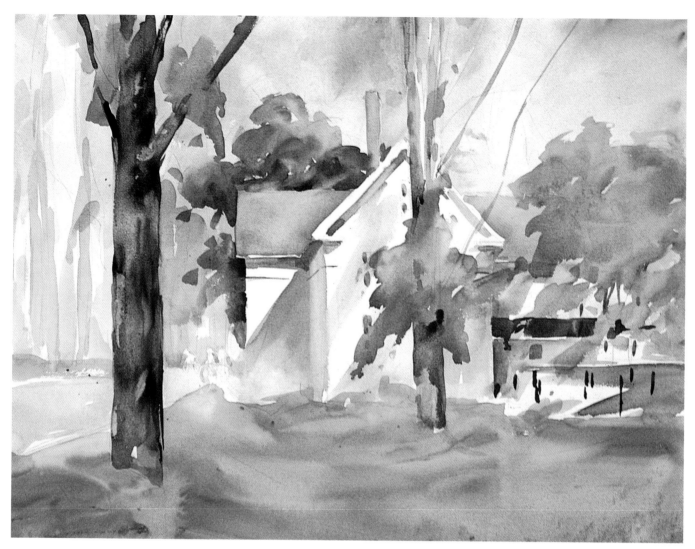

5 The dark tree in the foreground is now put in stronger than the dark near the house. The tree gets its strength because it is bigger. The roof and the L-shape of the house is painted, under the eaves of the house and tree trunk closer to the house. The details are started.

I have now started the trees in the background and set the color and value patterns so they lead me on a diagonal to the house. Do I think of all these things? No! Through all the years of painting and thinking, they've become subconscious servants to help me and keep the excitement going.

DETAIL 2. We can see tree diagonals and space behind the fence and the house.

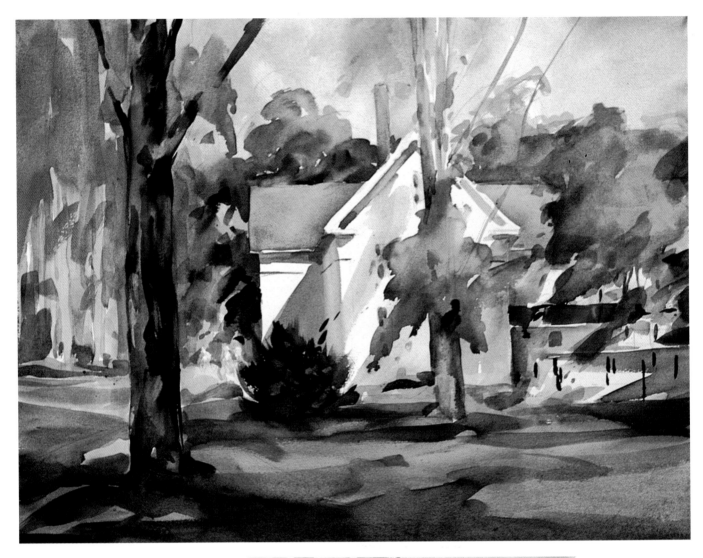

6 Shadows are now cast. I do this last because these shapes and values help lead me where I want to go and this creates abstract patterns in my very realistic landscape. Here you can quite clearly see the influence of the blue sky on my lawn. So far, so good. The painting is working.

DETAIL 3. The roof, the losing of an edge and the color change in light

The Finished Painting. I have now finished all forms adding more shadow accents on the tree branches and finishing the background trees.

In order to concentrate your attention on the two horses, I painted the background trees with little contrast and lost and found many edges thus losing and finding the trees in the snowy air. I also broke the area that connects the horses' hooves to the snow and kept them from being too obtrusive. Although on such an overcast day the horses' heads would be fairly dull in value, I purposely let the white paper show, knowing that the contrast would attract the viewer's eye to my center of interest.

Light on Horizontal and Broken Planes

LIGHT ON HORIZONTAL AND ANGULAR PLANES.
The field in the foreground is in shadow with light and shadow breaking up this plane. We then leave the shadow and move through the horizontal sunlit field to a group of upright bushes and trees and then finally to the New England homes.

Demonstration

3

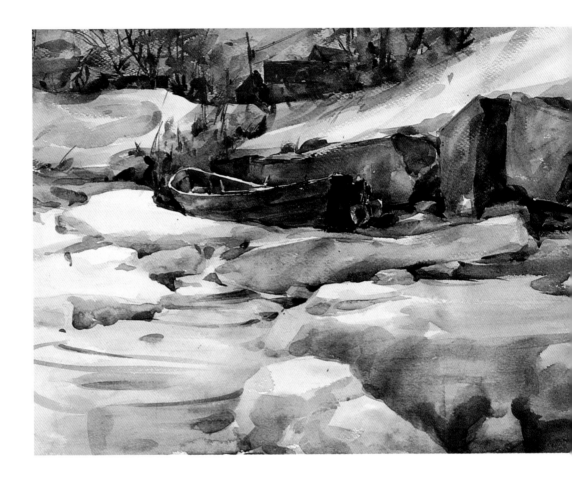

*T*his is a studio picture, developed from color sketches made on the spot. What

particularly interests me in this painting are the forces of snow and ice that pushed

the dory up from the shore and wedged it against the sea wall

LIGHT. The day is overcast, with a break in the distant clouds. Light comes down the background slope and enlivens the area around the bow of the boat (my center of interest). The strong light in this part of the picture keeps the design from becoming too soft and quiet. The horizontal up planes in the foreground receive all their light from the warm, clouded sky. In the studio, I arbitrarily chose to make the sky red (it may have been much cooler in reality) because I needed a warm note to balance the cool color in the snow and ice. Since the rock wall and boat are solid objects, they'll also be hard edged. It's a cold day and a certain number of hard edges will suggest that there's been very little melting.

KEY. This is a middle-key picture, mainly played around middle C. There's a general lack of sunlight and that rules out strong contrasts in light and dark. I go almost as light as I go dark, without touching black. The picture is thus a study in close values.

PAPER. The painting was done on Saunders 200-lb rough paper. It's a very soft paper, just right for this kind of a subject, since it absorbs color and naturally resists strong value contrasts. I also need its rough-grained surface. I plan to use rough-brush marks to texture the distant trees and to soften the edges of the snow. In order to get a smooth wash on such paper, you have to apply a little extra pressure to the brush; you'll sense how much after a little practice. This is important, for I want to cover the paper in the early washes. Remember: white specks break up your light pattern and confuse your design.

PRELIMINARY SKETCHES. The preliminary drawing is very important in a picture of this sort; each plane takes a different value and color, and I want to know exactly where each is when applying my washes. In order to prepare myself, I often do a lot of on-the-spot sketches. In *Figures 39 and 40,* on the following page, for example, I use a quick and convenient sketching method taught me by my friend Margaret Williams. The rough sketch is first blocked in with charcoal, then plain water dilutes the charcoal into a series of washes. Chinese White lightens values; extra charcoal sharpens an edge. I concentrate on the facts when doing such sketches; I don't worry about composition. Once I begin to understand a place, it naturally suggests compositional ideas to me. That's better, I think, than my trying to force a place into a favorite compositional formula.

In the preliminary drawings, I wanted to suggest the force of the wind and ocean. That's why I decided to paint the subject from the vantage point of the ice. I could have painted it on the bank; but I wouldn't have been involved in the material. This was the most expressive angle I could choose.

(Figure 39) Using charcoal, clean water on my brush, and Chinese White, I can make rapid on-the-spot studies of planes as they move in and out of the light.

(Figure 40) I paint such subjects exactly as they are in nature; they're explorations of a spot, not exercises in composition.

1 I exaggerated the drawing to show that even with a drawing (dark marks strong in the foreground and also darker at the boat nearest to us) we can tell about space with mere line.

2 I start with the broken piece of ice in the center of the painting (Thalo Green, Cobalt Blue, Yellow Ochre, and lots of water). Since the ice is translucent, these out-of-light washes will be lighter and warmer than the out-of-light areas of snow. The ice darkens toward the top, where a layer of snow blocks the light; Cobalt Blue and Yellow Ochre indicate the decline in translucency. Alizarin Crimson is used to darken the wash in the lower right and suggest traces of harbor mud. Note the softness of these edges compared to those of the broken pieces of ice. The sky is warm (Yellow Ochre and Cobalt Blue with Cadmium Red predominating). The sky color touches the background snow, losing some of the edges.

3 I work up the snow, establishing the relationship between snow and sky before I add any real darks. I carefully preserve the whites, since they lead into the design like stepping stones. The grayish snow (Yellow Ochre and Cobalt Blue, with a touch of Alizarin Crimson) is applied with a swinging stroke, a stroke that expresses the effect of the wind. As the planes of snow become horizontal, they catch more of the warm light of the sky. I add more Cerulean Blue to the snow nearest us; the added color brings the snow closer by making it more exciting to look at. Within the snow washes, the edges are mostly soft, with some dark added to tuck the drifts under.

DETAIL 1. I model the snow bank, making it cooler than the ice, but not so cool that it becomes a "pretty" blue. I claim one sharp edge, where the sun hits the snow. The background houses are dark, but not so dark that they jump out at you. Some hard edges indicate the solidity of the houses; water is also thrown into the wash to lose a few of the edges. Yellow Ochre and Cobalt Blue are used for the house nearest to us; Yellow Ochre and Cobalt Blue in the house farther back. I want a suggestion of color differences but not an unrelated collection of colored spots.

4 I work on the wall and the background, still holding off on the no-light areas in the snow. The wall is painted with Cobalt Blue, Raw Sienna, Alizarin Crimson, and a lot of water. The face of the wall catches a lot of reflected light from the snow; it's therefore warm in color. The sides of the rocks, however, don't catch as much light, and are therefore cooler. Notice that the mass of the wall slants downward, thus leading your eye toward the boat. The trunks of the distant trees also angle inward, funneling the viewer's eye toward the center of interest.

DETAIL 2. I move to the background, working all over the paper and never finishing any one area. The tree trunks are painted first, with both wet and rough-brush strokes suggesting bare branches against the sky. You sense something is happening, but you don't see specific bushes and trees. Notice how the colors of the trees, houses, and snow bank are all closely related; the color ties the objects together.

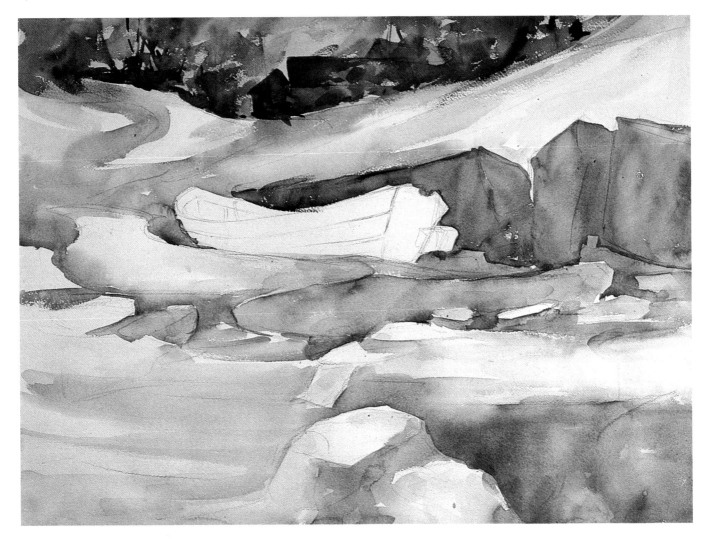

5 The blue boat (Cobalt Blue and Raw Sienna) is the focal point of the design — everything leads to it. The boat is old and weather-beaten, so I don't mix the colors too thoroughly. The strokes follow the direction of the boards that form the boat. I develop my out-of-light darks (Cobalt Blue, Raw Sienna, and Alizarin Crimson, with some Yellow Ochre added to vary the wash). The strong no light darks at the bottom of the boat and the wall indicate where the snow and man-made objects lock together. Clumps of grass (Raw Sienna and Cobalt Blue) are suggested near the bow of the boat; they're just pleasant marks, rather than an attempt to draw each blade of grass.

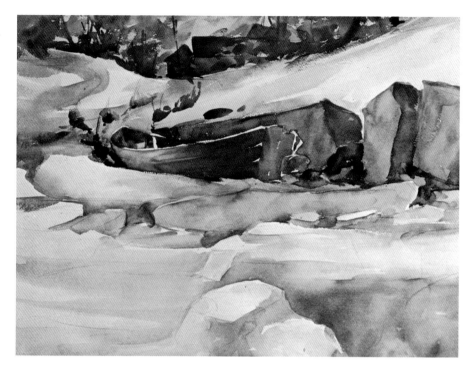

DETAIL 3. As the blue boat turns, it catches a warm (Cadmium Orange) reflected light from the snow. The light bounce is strongest near the bow where the boat cuts sharply under. As the area sets up, I further lighten the wash. I also work on the inside of the boat. This area is a key color — it's rich, attracts the eye, and gives the whole picture a boost. I use Alizarin Crimson and Yellow Ochre for the in-light color; Yellow Ochre and Cobalt Blue for the out-of-light side. I finish the area while it's wet, losing sharp edges and breaking up the wash. Perfection wouldn't suggest the boat's age and hard use.

6 Now that my darks are established, the large central block of ice looks too light; I glaze over it with a wash of Cobalt Blue, Alizarin Crimson, and Yellow Ochre. I paint the dark stern of the boat (Raw Sienna and Ultramarine Blue), getting the wash down and then dropping additional warm and cool color into it. I lighten the side of the boat (the first wash was too dark) and vary the edge where the boat and snow meet. I work dark, rhythmical marks over the foreground (Cadmium Red and Cobalt Blue), emphasizing the effect of the tide; but I keep the marks from becoming too important by connecting them through both line and color to the out-of-light sides of the nearby drifts.

DETAIL 4. I concentrate my interesting shapes (grass, house, and trees) near the bow of the boat, my center of interest. The grass is painted simply, but it attracts the eye because it's a dark mass against a light one — and a warm color against a cool color. These tufts of grass also connect the boat, wall and background. All this visual activity draws the eye to the center of interest — without it, the area around the boat would be of no more interest than the wall directly to its right.

DETAIL 5. Rough-brush marks now help pull the painting together. I work over the rocks, the snow, and the ice; reducing the water in the wash and lessening the pressure on the brush so the color catches the surface of the paper. You can see how this breaks up the surface of the rocks and makes them look chipped and broken. Dark no-light marks show where the wall tucks under. To the right, a quick horizontal rough-brush mark softens one of these no-light edges. A hard edge so near the frame would attract attention from the center of interest. Notice that the snow washes are applied in a hit-or-miss fashion. The variety in color and weight of paint suggests where layers of snow overlap and move in and out of the light.

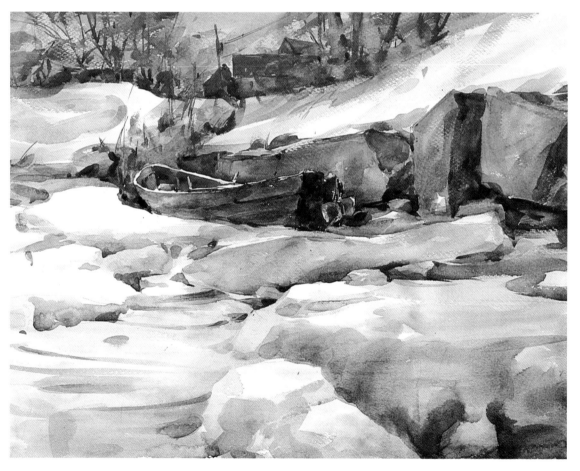

THE INDIAN POT. Transparent Watercolor with Gouache.

This "gouache" is merely Chinese White mixed into the colors of light, the warm light and the cool light. I call this "body color." I loaded my round number 8 brush with cool color and touched all the objects on the side closest to us. This gives dimension to the painting because the edge away from us seems to go farther back. I kept moving with these marks back and forth around the painting so these marks, if all else were eliminated, would balance the paper in marks alone. I did this also but with a much lesser degree to the warm lights. This is a transparent watercolor with "gouache" accents added. The transparent watercolor is dominant.

Expressive Color and Edges

THE OLD LAMP. Watercolor with Pastel

Many times as we paint, after investing hours of work, the painting just "doesn't have it." I had wanted very warm and intense colors with a feeling of drama created by the light. It did not happen and my spirits have dropped. All is lost — or that is the way my emotions play with me. But then I remember that it's a watercolor and so very compatible with pastel additions. I try to hold the highest lights and also those colors so full of form in the light to be the watercolor. Modeling darks and a feeling for air and space is where the pastel comes to help in my painting. The pastel can give me the most subtle and the most vibrant of colors. Always remember to make more of one — the watercolor or pastel — but never equal. This picture is now a pastel with watercolor.

Demonstration

4

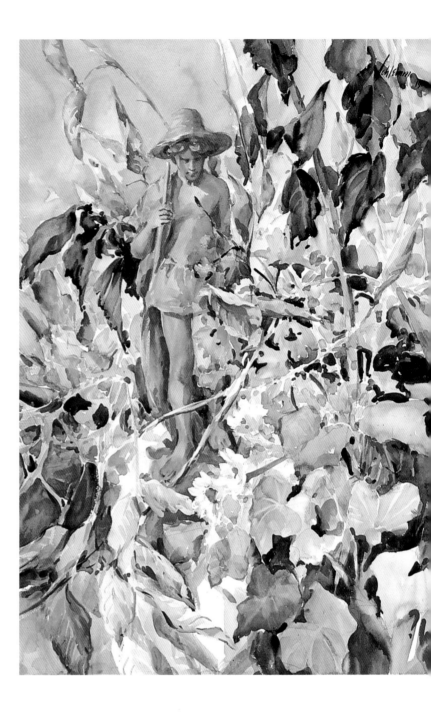

This is a painting of a garden statue that my classes gave to me in memory of my father. I painted it with variations of warm and cool greens, so serene, accented with the warms coming from the terra cotta.

LIGHT. I placed the spotlight far from the still life so that a soft warm light that's not very strong would play upon the forms. The shadows are more to the gray cools that show the terra cotta color underneath.

A light high in the painting, the sky, forces your eye to move up into the painting, suggesting life and growth. The statue is clearly the subject of the painting.

Because the spotlight was placed far away, objects seem to move in out of the light. Leaves and flowers merge with each other making patterns of their own. The essence of fullness is in the composition. It took much planning of lights before I began.

KEY. Our main colors are yellows and greens in a lower midtone range, perhaps starting with middle C. This makes the white flowers come forward. The statue, being in the light and thus warm and painted in full form, is without any doubt the subject of the painting.

PAPER. I did the painting on 140-lb Arches cold press paper. Since the subject is complicated, I may have to make corrections and so I am careful not to make the colors sink into the paper but lay untouched washes which stay on top.

PLANNING THE COMPOSITION. This painting could become a hodge-podge of shapes and colors so I had to be very careful in planning. What did I want to say? Of course, the statue, and so I placed it first. That is what the viewer must see first. I intend to work up, in all its form, the statue of this young boy and so some of the leaves and flowers will be less developed. The greens will become the dominant color. Please notice on the pages that follow the green in the lower left corner; it's painted with much detail. This is to set up the space in the painting, to start these and then move into and through to the statue, past flowers and leaves, to the sky.

PRELIMINARY STUDIES. It's very important to study the subject with drawing before you paint it. If you know it well, you can paint it more freely. That's important, for we're trying to paint light on form — not light on an outline. .

Form is also important when I draw the leaves. Notice that the leaves on the upper right in the drawing are thin and spiky, while those in the lower right are wider and more rounded. Each must be drawn in a way that expresses its unique character.

Of course, when I draw I look for more than the shape of the individual flower. I'm really interested in the flow of the painting as a whole. I don't just place the flowers anywhere. Notice the groups of leaves and flowers that cluster in front of the statue in order to set the statue back from us. They curve from the lower left and down from the upper right. These lines form my main directionals.

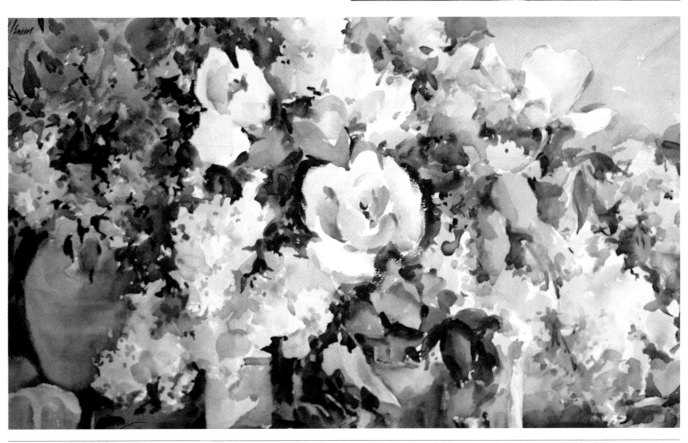

VARIOUS SHAPES OF FLOWERS
AND LEAVES IN AND OUT OF THE LIGHT.

By starting to draw flowers with a few simple

geometric shapes, I immediately think about

three-dimensional form rather than

two-dimensional outline.

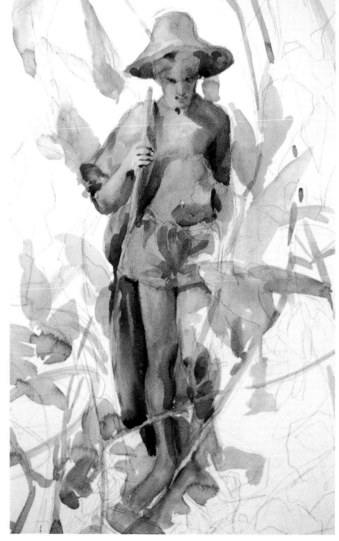

DETAIL 1. Here is a closeup of the statue at the stage before I go on with the painting. If I miss on this step — such as painting the statue badly — I would start again. I do a little more at this time with the modeling and then go on with the rest of the painting.

1 Just a beginning, but it has been said that a good beginning is worth half the finish. And so, always strive for a good and thoughtful beginning. After the drawing, much time was given to this, especially the drawing of the statue and placement of all objects.

Now you can see that I begin by laying in washes of the color and value of the statue in the light, already beginning to feel out the forms and also the movement of the foreground leaves and twigs. At this time, I am after the composition right from the start. You will notice that the paper is now completely composed or "balanced." The areas of the white paper are working with the warm colors of the objects. If I were a modern painter, this step could be called "figure and ground." It is most important at this step to activate your entire paper; don't paint all objects one at a time and hope for a good finish. We are creative painters and not merely those who could fill in a drawing with color.

2 The foreground is very important. Those large green leaves are painted with detail; I must feel them to be closer to the viewer than the statue. The fastest way to send anything back is to overlap one object in front of the other. I have used this with the foreground leaves, the foreground twigs and then the statue overlaps the dark green leaves behind it in the upper left. We move down into the painting with dark leaves coming down from the upper golden section. You see, we never stop composing with color and value and pictorial space, light and air.

3 The painting is now progressing nicely. I have created interest in the leaves and flowers to balance the statue by the open and closed areas next to the statue on the right. Also, I have some of my darkest and lightest areas here in these "closed areas." Then they open as the leaves rise up and down. It is so much fun to think in these more abstract terms than merely paint flowers and leaves. A faint wash has now been dropped into the background so the light warm leaves will "come forth" in the upper right.

You can see the large pot has warms and cools painted on it in its modeling. The cool is a light coming from the sky.

DETAIL 2. This is a detail of the "closed areas" of the flowers and twigs used to balance the statue. Furthermore, the open areas are where the objects move into the background space. I truly love composing this step.

DETAIL 3. The statue completed. We feel the flowers are in front and they are done in little detail to keep them free as if the wind could blow them gently. The leaves are helping the statue by taking vertical directionals, helping the painting's quiet mode and leading to the statue.

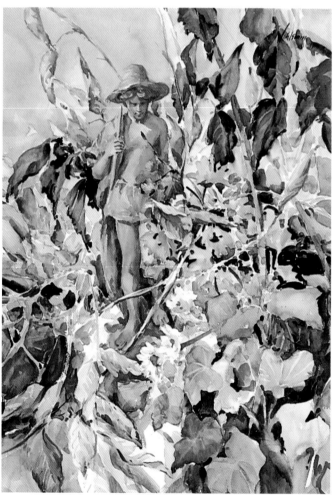

DETAIL 4. The entire right area of the leaves and flowers in light, space and air. The warms and cools, lights and darks, directionals, open and closed areas all are working. I have enjoyed painting this tribute to my father. The statue was given to me with love by all my students.

4 The finish. I have added dark lines suggesting shadows to accent further the dark side of the twigs in front of the statue and lower sides of the leaves. I have done at this time the best I could. It is free and clean — a watercolor — and so now is the time to stop.

I was struck by the constant changing of values and even slight changes as this still life moved in and out of the light. The drape in the foreground had all light blocked from it and so became even darker than the fifty percent value. Remember, everything in the light is lighter than white in shadow and everything out of the light is darker than white in shadow, white in shadow being a fifty percent value. However, the foreground drapes break this rule as does the part of the white vase; the light could not even affect this color. This was done because the spotlight was so close to the background plaque and drape that it became more like studio lighting.

How White is White?

How White is White?

STILL LIFE WITH SWAN.

This imaginative painting was done because of the swan sculpture; it was so beautiful. I tried to put all things of beauty in it. The columns always remind me of time, and the sky area to the left allows me to escape for an instant from the painting only to be drawn back by the brass container in the lower right golden section area. The oranges and greens force my eye there. There are very few places on this painting — small areas here and there — that are the white paper. All the whites are painted in warm and cool grays being careful of the shadow and reflective light and the space they are in.

Demonstration

5

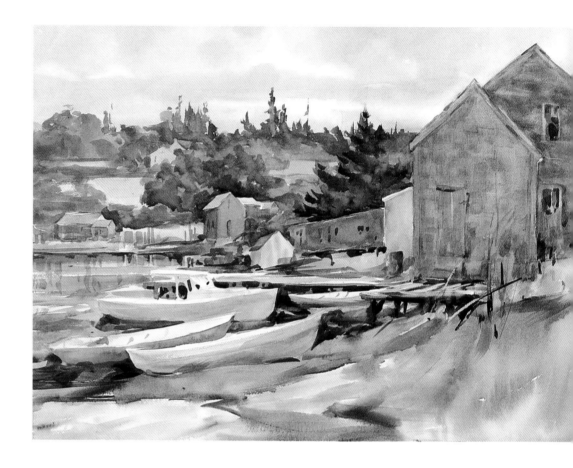

 n this demonstration, we'll look at the light on a completely overcast day and

examine the question of just how white is white — a problem many students

have when they deal with white areas not directly in the light.

LIGHT. The atmosphere is heavy, and veils of moisture neutralize the warm of the sun, actually causing the course of light to become a more cool color but never cold. If the day were slowly to clear, the dissipating moisture would let more and more sunlight shine through. The sides of the houses, being upright planes, would be darker than the sky. Depending upon the position of the sun through these "veils of atmosphere," the houses may be warmer or cooler than the sky. As the day begins to clear, the houses begin to be warmer still. And when the full sun comes out, we would then have a sunny day effect of warm light, cool shadow.

THE WET-IN-WET APPROACH. Since the
light is cool but not strongly colored, I do not do much glazing, only modeling of the form in space, light and air. I painted this out-of-doors on a very damp — near rainy — day. Because of the moisture in the air, the painting would not readily dry but remained wet for so long a time that I had to use a method of painting that I learned in my first year of painting with watercolor. I did not start this way; I quickly moved into it. This is the procedure:

To prepare the paper for wet-in-wet painting, first wet it three times on each side with a soft, natural sponge and place it on a Masonite board, cut slightly larger than the paper. (If the edges hang over the edge of the board, they'll dry before the rest of the paper.) If the paper buckles and shows air bubbles, you haven't wet it enough. Drop more water between the board and the back of the

paper; if you keep adding water as you paint, you can keep the paper wet indefinitely.

Don't tape the paper to the board! The wet paper adheres naturally and, as you paint, will continue to stretch for about a half hour. When it finally lies flat, before you begin to paint, go over the paper with a soft, natural sponge, both horizontally and then vertically. You can start to work on the paper as soon as the glisten leaves the surface. If you want an area to dry more quickly during the painting process, use tissues to pick up the excess water; do not use rags. Once the paper has begun to dry (after about a half hour), apply four clips, two on the right and two on the left-hand side of the paper near the top and the bottom. They place the paper under an even tension and keep it from buckling.

KEY. This is a minor, middle key painting, not too light or dark. There is not any strong light to create these contrasts. I won't use either brilliant whites or deep blacks. The lights and midtones cluster a little above middle C; the darks are farther down the register. Because the interval between the darks and midtone values is greater than that between the midtone values and the lights, the darks naturally pop. This is appropriate for the day (on a wet day, the darks are usually rich in color) and also gives us a nice dark compositional pattern. In *Figure 41* (page 90), you can see how light the sky, water, and boats are on a sunny day; their colors, forms and values are very different on a gray day.

PAPER. I used Arches 140-lb cold press watercolor paper. It's a paper that has a good surface and can really take a beating; it needs strength to stand the wetting and sponging of the wet-in-wet method. The fairly textureless cold press surface is also useful since, unlike in the demonstration where I painted snow and ice, I don't want a lot of rough brushing in this picture; such strokes would suggest a shimmer that is inappropriate for the dull light of the day.

PLANNING THE COMPOSITION. With the

boats, pier and landscape, getting things together is important; I skimmed the paper with my pencil to find each area to put every object in its place for my landscape. After that, I do a good drawing. The sky, the water and land are the first places to go after, then the placement of the boats and shacks. I emphasize the hill by placing it high in the painting. After all, hills are high and I have kept the horizon line lower in the composition. I've added interest by using the strong, repeating horizontals countered by the verticals to give stability and then the diagonal of the grassy shore.

Notice that the large house to the right of the drawing frames the composition. The smaller house to the left is interesting in contour — but not so interesting that it attracts attention. The real focus of the painting is near the center, where boats, water, pier and grasses meet.

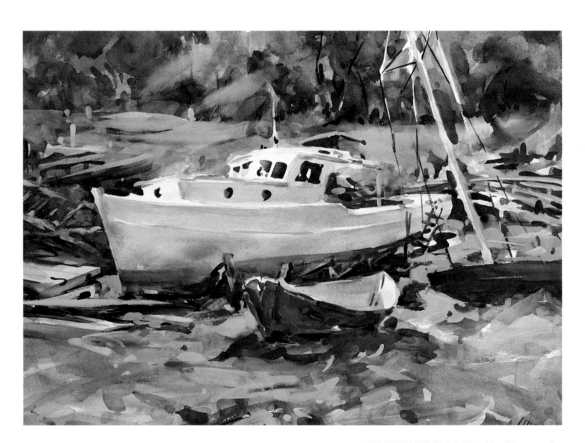

MONTGOMERY'S BOAT YARD. *(Figure 41)*

A sunny day, the subject is the boat but what made me paint it is the play of white in shadow on the boat. The little dory in the center sets up the space and the "bigness" of the white boat.

1 My drawing is finished; I always try to get the best drawing I can. It is the foundation of my painting. Now I stop and become quiet so that the day takes over my thoughts. I want that special day, the day I am there. The sky is painted first with the light and then the dark pearl-like grays of the clouds. The day is beginning to clear. I then move down to the harbor water; it is part of the sky color, a family of color that is different but influencing each other. The water today is a little darker, not much, and a little more cool color, but always the feeling of the sky. The rooftops and white houses are also similar to the sky, some lighter, some darker and so on with the warms and cools.

2 Now I reach for the white boats. Although white, it is a gray day so the upright planes, those against the sky, are darker. The top planes are very light because they are taking the full light from the sky.

3 The foreground grasses are painted, making sure the color is clean and not too warm. The greens have much of the sky color dropped into them as so much moisture made the grasses wet and the wetness becomes like a mirror reflecting the sky. As we move back with the earth's colors, we must have color in space. Do not have the same color in the foreground and the exact same color in the background. The houses, in their color and value of that special day, are now painted.

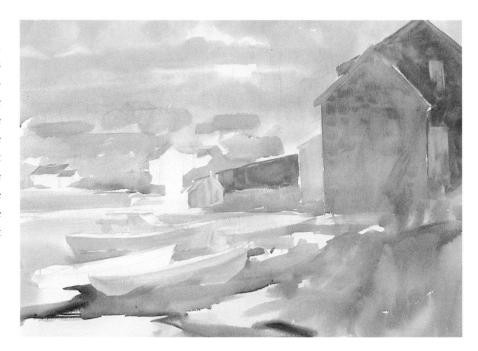

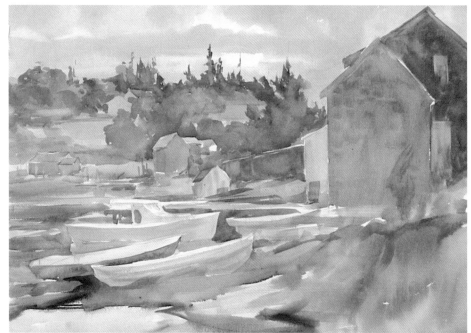

4 And now the trees: those great upright planes are started. Please be careful at this time not to lose the feeling of the great expanse of our harbor. Colors lose in intensity as they recede and the value jump becomes closer together. The pines are dark but I always try to be able to give a greater dark or greater value jump in the foreground for the picture plane.

DETAIL 1. This is a closeup of the area showing color and value perspective. The boat certainly is closer and we move back through many picture planes.

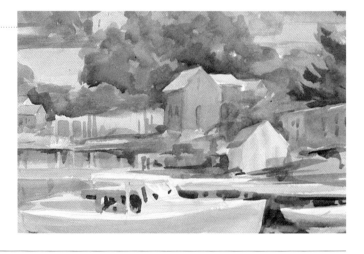

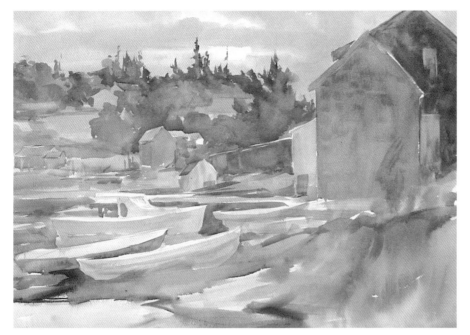

5 Now for the modeling, those wonderful darker values that give us form. While painting this step, try to observe how edges come together: are they hard, soft, rough-brushes or blended? A dark next to the white boat in the foreground gives us the value jump that helps to push the background back (where it belongs). My mind at this time can only relate to the darks.

6 *The Finished Painting.* I add detail and the strength given with this detail to direct the viewer's eye through the painting and to lift out of those areas that are not important. If we paint everything equally, the painting will become static and we will not be able to travel through the painting. I have now been able to say all that was important to me. The painting has the feel of the harbor and the day. I am satisfied to stop.

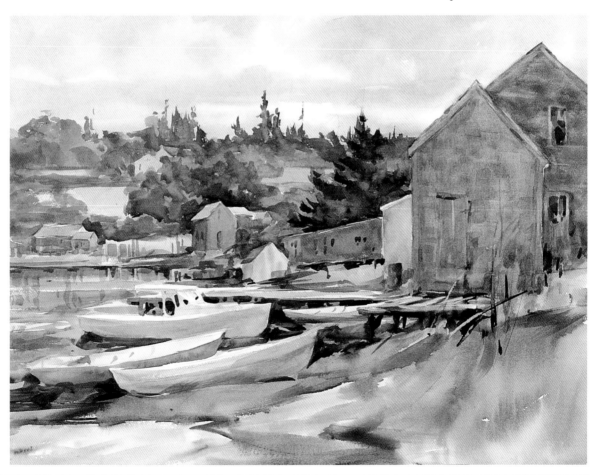

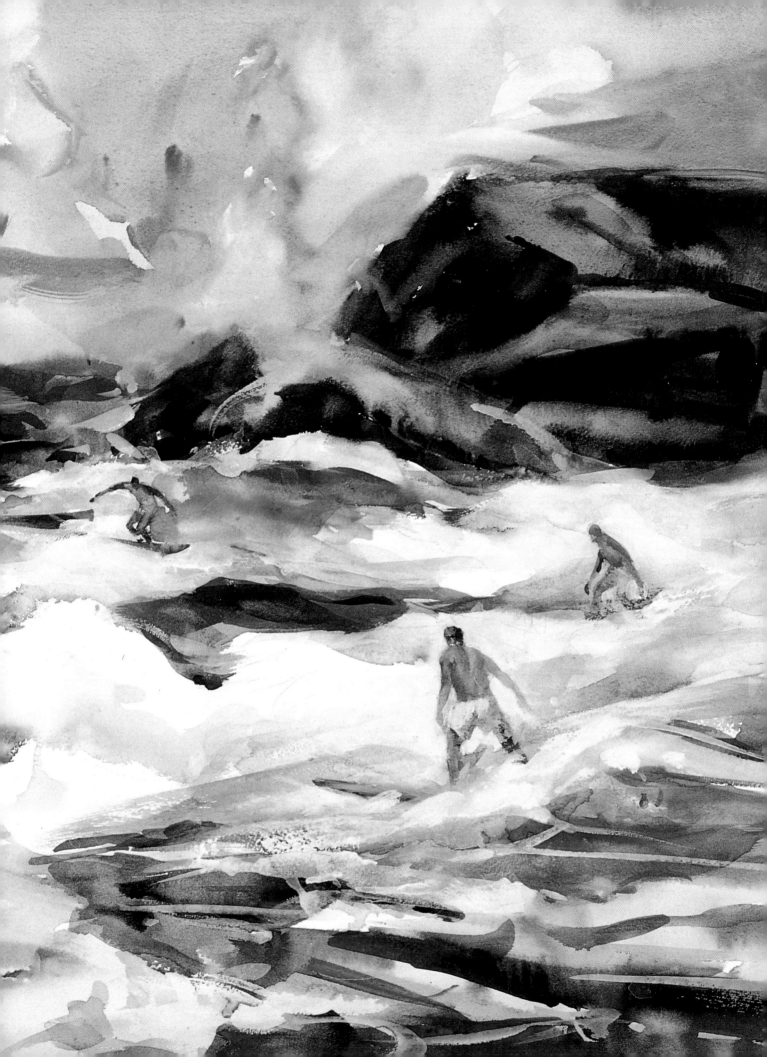

Light and Movement

THE SURFERS, GOOD HARBOR BEACH.

A day of tremendous activity. I painted this at the water's edge. In fact, the tide came in and I was literally part of it all — ankle deep in water. The waves just came crashing in — a delight to the surfers — and, consequently, the water was so white that day. To get movement into this painting, I worked with diagonals following the lights — the waves and the sky. Notice how, starting at the top near right of the sky, a white cloud on a diagonal moves down into the waves and leads directly to a surfer. The direction then takes a reverse repeat, almost exact to the foreground surfer and to the white wave. There is another triangle forming with the three surfers, holding them as a unit and yet, we still get the strength of the diagonals. Stability of this painting is formed by the implied line; a vertical from the blue sky touching the white cloud. It drops down to the bluish water breaking over the distant rocks and straight down to the center of the white wave. It's not as much in the light on the extreme left foreground. If you care to examine this painting further, it is filled with implied diagonals and implied verticals and a strong horizontal. I could not get all of this on location, so when I returned to my studio, I helped them out with white gouache used as white and cool white. This was a tremendously difficult painting for me to do.

Demonstration

6

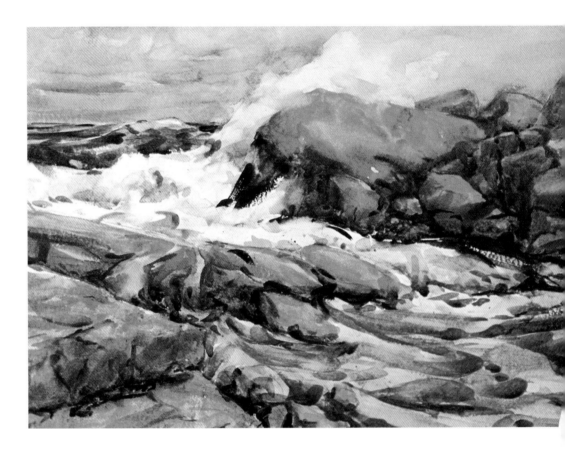

ow let's look at a spring day by the seashore. The storm is over, the sun has just come out. And since it's the kind of day that I like being outdoors, I'll try to get that feeling of exhilaration in the final painting.

LIGHT. The light in the painting is clear, but the active surf throws lots of spray in the air. I can't paint the moisture, but I can show how the spray affects the light, softening all the edges.

KEY. The midtones and lights are close together, spreading from above middle C to a few brilliant notes in the highest register. Foam and moisture in the air pull the values together. There's a great jump downward to the darks in the picture. I want these darks to sound, in the final painting, like the notes of a bass drum. These terrific light/dark contrasts add to the excitement of the day.

PAPER. I used Waterford 140-lb cold press paper. It has a hard surface. The paint doesn't sink in, and you can easily sponge down to white paper. That's important, for the water in a surf should be as fresh and clean as the petals of a flower. The color should sparkle even in the spots where I've had to make corrections.

PLANNING THE COMPOSITION. The rocks are placed first — they're the bones under the skin, the body under the hanging robes. If you understand the rocks, you'll understand why the surf acts as it does. It's like spending time in life class. In order to keep the surf moving, I use lots of active, contrasting diagonals. The ocean and waves, for example, angle downward into the picture, while the line of the rocks slashes across the picture in the opposite direction. (If the scene were a peaceful one, I'd use more static horizontal lines.) Notice in the drawing that the big wave is the center of interest; the eye then follows the wave as it crashes over the rocks and into the foreground pool. The swirling lines in this pool direct the viewer's eye to the right and left, curving back to the burst of foam. The motion is thus a circular one, a motion that suggests, to me at least, the endless activity of the ocean.

I also emphasize the long line of the rocks across the middle of the paper. These long horizontals suggest an expanse of space far beyond the limits of the frame. This feeling of spaciousness is an important part of your experience of the seashore.

Although two-thirds of the picture is rock and water, the sky remains a large piece — too large not to share in the excitement of the day. You can see the active pencil lines in it. I've indicated some horizontal movement in the sky near the horizon: these low stratus clouds give the eye a quiet place to rest after the activity of the other parts of the painting.

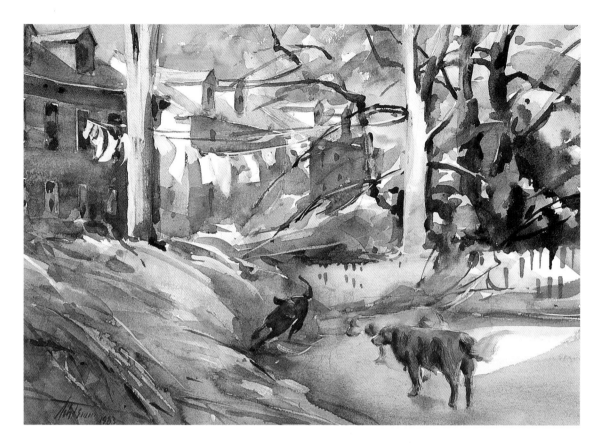

MY DOGS.

*This painting, for me, was one of the lucky ones. It was done out-of-doors
in my father's yard. The black dog was the most active animal I had ever
seen (or owned). His name, appropriately, was "Spunky." I painted the
Golden Retriever, "Missie," twice in order to have three dogs in the com-
position. One, the black one, dominates, the other two form one unit.
It was an afternoon that was bathed in light — warm light — making
the trees stand out; they lost their gray color and took on the values and
colors of the late afternoon light — a delightful time of day for color.
The painting takes a large — almost one-half — circle to create move-
ment. The circle is the path of light. The small shadow to the lower right
in the fence and road also takes on a near one-half circle. Oh, if there
were only many days like this when paintings just seem to happen.*

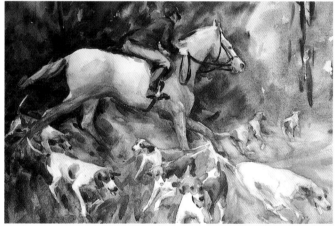

AN OCTOBER HUNT.

*The dogs have scattered in every direction, the use of diagonals opposing
each other. Even the sun-drenched field is on a diagonal and the square
is used to bring us into the distant field again with sunlight. The
foreground dog, running towards us, leads us into the painting with a
golden section implied line straight to the horse's head. We are held in
this painting because the values and rich darks are around the horse's
head and the front of his massive chest. This, of course, was a studio
painting done from sketches and photographs that I put together.*

1 The painting has a lot of strong rocks in it, and I'll suggest this strength through hard edges. Too many hard edges, however, would make the picture stand still. So I have to balance this need for strength against an equally important need for softness. I keep the drawing to a minimum. It tells me where I'm going, but also gives me a chance to work freely with the paint.

2 Since I can't paint the whites in a watercolor, I use the out-of-light parts of the surf (Yellow Ochre, Cerulean Blue, and Cadmium Red) to help me visualize what these whites will look like. They're very important parts of the composition and I want to make sure they have interesting shapes. The heavy, opaque colors dry at different rates; they separate in the wash and create interesting textural effects. I get variety in the grays by using more Yellow Ochre, for example, in the churning foreground pool. Such variation suggests activity, without my needing to draw what's going on. My brushmarks follow the direction of the surf. I may lose some of the marks later, but they'll be felt under the glazes and will help keep the surf moving. Notice that the washes darken near the bottom of the surf, where the water turns from the light. The watermarks suggest additional activity in the surf.

3 I erase the pencil marks from the sky; if I tried to remove them later, I'd lift my color. The clouds are a gray made of Yellow Ochre, Cerulean Blue, and — for variety of color — Alizarin Crimson. I first claim the edge where sky and surf meet, losing parts of it and accenting others. A hard-edged burst of surf would look like a powder puff. I then work freely into the sky. While the clouds are wet, I add the color of the sky. Cobalt Blue is at the zenith; Cerulean Blue, farther down; and Cerulean Blue and Thalo Green, near the horizon. At the horizon itself, I add a touch of Cadmium Red, a hazy, rosy color that pushes the sky back for as many miles as the eye can see.

DETAIL 1. Sky color reflects onto the water. I'll later pull the blue ocean over it. Watermarks texture the clouds to the far left; I liked them, so I left them alone. Notice how the sky color is breaking apart. Some students worry about "perfect" washes and are shocked when their colors begin to separate. They nervously try to brush them back together. Don't worry about perfection; worry about light and air.

4 I wash in the big rock areas with Yellow Ochre, Cadmium Red, and Cobalt Blue. The cool Cobalt Blue takes the hotness out of the color. The pigments are heavy in the wash, so I can later use water to lighten areas — without the water diluting the wash back to white paper. There's more Yellow Ochre in the in-light parts of the distant rocks, with Cerulean Blue added where they turn from the light. I use more Cadmium Red to bring the rocks on the far left nearer. I add Raw Sienna to the foreground rocks; the strong color also pulls the area forward. Notice how some of the color reflects into the water. The rock washes are messy — they help express the character of the subject.

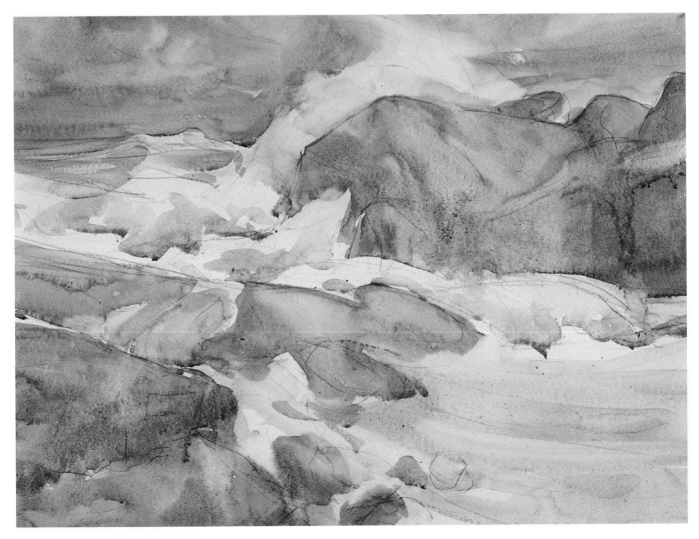

5 The out-of-light and no-light areas of the rocks are made with varying mixtures of Burnt Sienna, Ultramarine Blue, and Thalo Green. Cadmium Red sometimes warms the mix and suggests light sneaking into the crevices. The rocks are wet and dark near the water (Ultramarine Blue, Burnt Sienna, and Thalo Green). I think of these darks as directionals first, and as "rocks" second. Notice, for example, how the darks on the far right swing around and back into the picture. The out-of-light darks in the flat center rock also lead you up and toward the crashing surf.

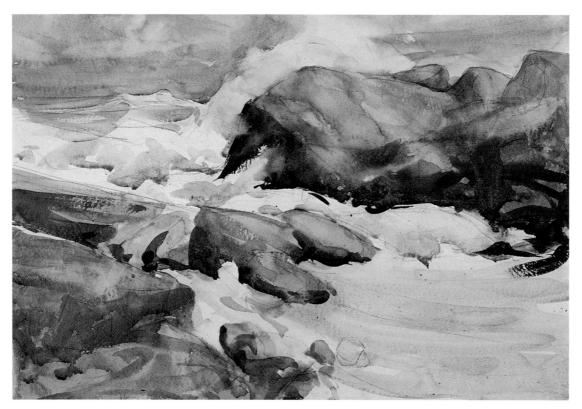

DETAIL 2. The dark near the center of interest is the most important edge in the painting. It has to be strong, yet also touched by mist. I therefore vary the edge. It's hard near the water, but softened by a rough-brush mark and actually broken by added water near its top. There are two kinds of light in this area: Cobalt Blue — representing the skylight — bounces into the dark from the nearby water; Yellow Ochre suggests the bounce of light from the sun. A rough-brush mark adds texture to the foreground rock.

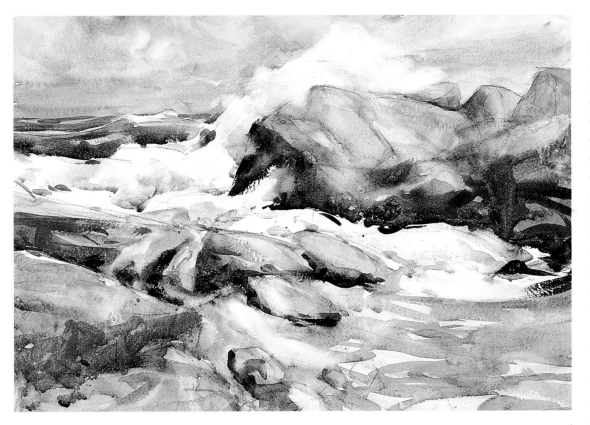

DETAIL 3. The ocean is clearly swelling over the rocks. To paint it, you have to understand how underwater rocks are formed. As the water rises, it catches the light (Yellow Ochre – the light – warms Thalo Green – the water – while a touch of Cadmium Red grays the mix). The foreground cracks where rock meets rock are the only true no-light areas in the picture (Ultramarine Blue and Burnt Sienna). Almost everywhere else, reflected light manages to find a way in. Notice how some edges near the water are soft, others hard. Mist or spray naturally affects these edges. You have to show this effect or the viewer will feel as if a piece of plate glass is separating the rocks from the water.

6&7 The burst of foam seems too violent in its motion. I hate to touch the sky and thus dull it, but I feel the correction is essential. I also soften the edge of the boulder to the right of the burst of foam (notice the amount of Cerulean Blue sky color in the out-of-light areas). Using Cobalt Blue and touches of Cadmium Red, and Yellow Ochre, I bring the wave into relief by painting the background water. I break the horizon, preventing it from becoming a hard, distracting line. I mix more Yellow Ochre in the mix and accent the lively, churning action of the foreground water. I also darken the water on the lower left, obscuring the edge where rock and ocean meet. I don't want strong contrasts in a subordinate area.

I add darks to dramatize the picture, glazing dark washes over some of the rocks and working up my out-of-light and no-light areas on the right (Ultramarine Blue, Cadmium Red, and Burnt Sienna). The accidental marks in the wash suggest shapes to me. I also sharpen nearby edges and further accent the circular motion of the tidal pool. These foreground swirls are painted with a big stroke. Notice, however, that I use a number of small strokes, too; they add variety and also move the eye into the picture.

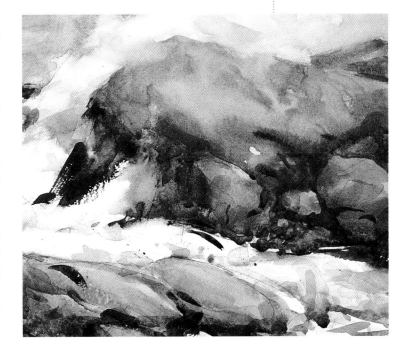

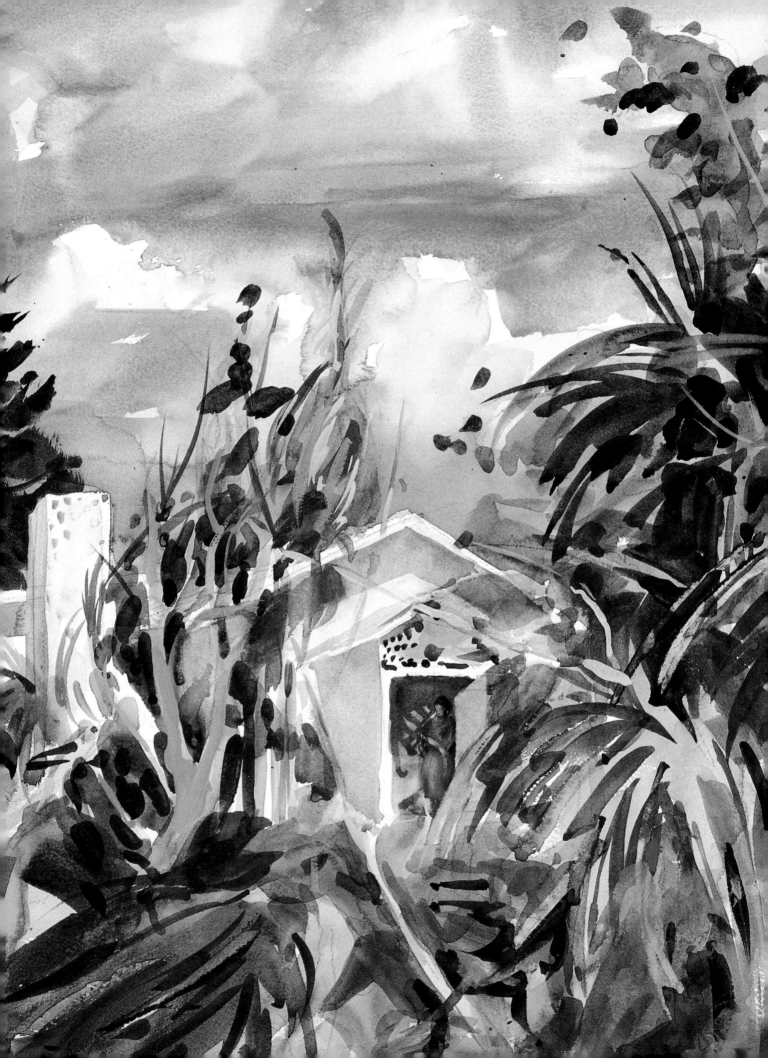

Flickering Light

Flickering Light

THE FLORIDA HOUSE.

The light is coming from the right and is high in the sky, touching all the top planes of each of the foreground palms and tropical leaves. It then enters the doorway. I have used this light to form a V shape entry in the center of the painting. This painting was done on location; it was done quickly as the light is always fleeting. The painting is made mostly of warm and cool greens. As we approach the foreground right, I try to use the richest and most colorful darks I am able to paint. This is the closest area to us and with the shapes of warms — the warms of shadow color — they are much cooler than the warms of the light, but intense. I try to be able to go through these areas of leaves and palms as if I were pushing my way through them to the other side.

Demonstration

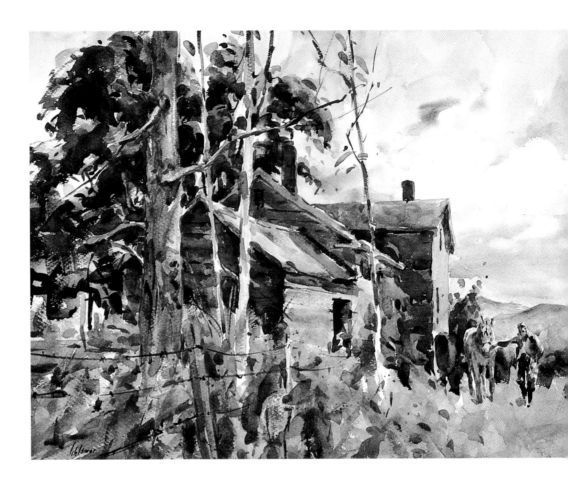

Wind and clouds give a feeling of moving, flickering light to a scene. When I paint the following demonstration, I'll try to capture the lively feeling of summer, the season when you want to go out and do things.

LIGHT. This is a summer day with a brisk breeze. In order to suggest the shifting, moving light, I use a lot of broken edges, trying not to latch on to individual objects. They'll be an important expressive element in the painting. When there is an edge, it will be fairly crisp.

KEY. The values cluster around middle C, with few bright lights or real darks. Such a key fits the old, weathered character of the barn. I'll get excitement within this restrained key, however, by using decorative marks to suggest the dappled light.

PAPER. The picture was painted on Saunders 200-lb rough paper. It's a soft, absorbent paper that automatically quiets my dark washes.

PRELIMINARY SKETCHES. Before painting the farm, I explore the area through a series of quick color sketches, no more than 6" x 7" in size (*Figures 42 and 43* on the following page). In *Figure 42,* I found the composition had too much uninteresting foreground, a fact I'd hate to discover after doing a full-size watercolor. Similarly, I knew I had a good idea in *Figure 43,* but I also saw that it wasn't a stable design. In the actual painting, I added the horse and man as balancing elements.

PLANNING THE COMPOSITION. The final drawing isn't very elaborate. I want to be free to experiment as I work. I put in a lot of sky, for that gives the painting air and a feeling of the outdoors. As in the previous demonstration, the sky will also contribute to the excitement of the day. Notice, also, how the diagonal movement of the clouds acts as a foil to the dominant verticals and horizontals of the trees and buildings.

The trees are grouped in uneven units — three to the left of center, one to the right. As already noted, the man and horse balance the mass of the building and help keep your eye in the picture. I try to make the figure move by drawing him off balance and by using curved, relaxed lines. These lines make him look like a living person, not a stick figure.

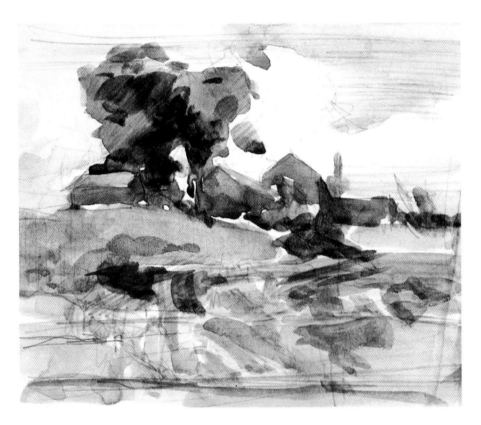

FIGURE 42.

A rough color sketch done on bristol board. By massing in the design, I could see that my fore-ground was lacking in interest.

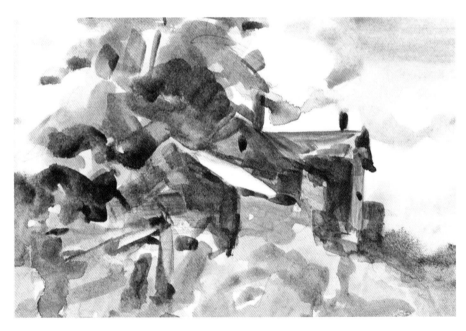

FIGURE 43.

Here the idea looked good, but I needed to add something to keep the viewer's eye from shooting out of the right-hand side of the picture.

1 Strong verticals and horizontals interlace, like material in a carpet. They hold the picture together. The angularity is relieved by the diagonals of the roof and sky and by the rounded movement of the masses of foliage. Before starting to paint, I erase the pencil lines from the sky. They helped me determine how the sky will look, but I don't want them showing through the later washes.

2 The saplings are painted with Yellow Ochre, Alizarin Crimson, and Cobalt Blue. In the big tree, the stronger, deeper Raw Sienna replaces Yellow Ochre. As the large tree turns from the light, I cool the color by adding more Cobalt Blue and a touch of Cadmium Red. The foreground logs are directionals, pointing the viewer into the picture. They're connected to the foreground post which, in turn, is connected to the big tree. The objects are unified by the light, rather than isolated by it. I also paint the similarly colored roof, horse, and man. Where the roof turns toward us, it catches a lot of warm reflected light.

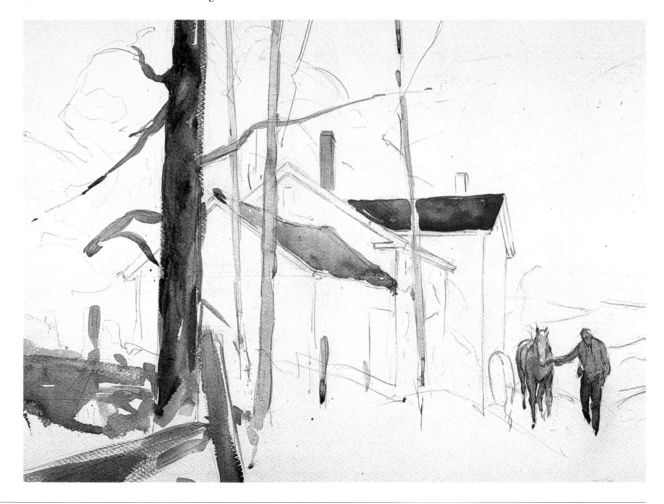

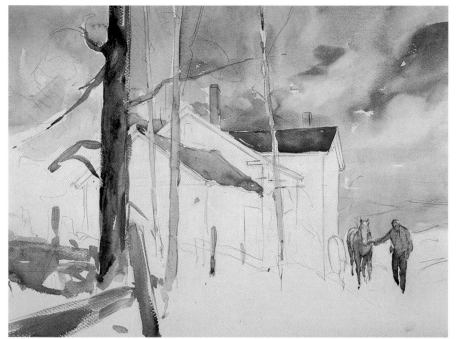

3 I begin the sky early, for it determines the quality of the light. I wet the sky in a hit-or-miss fashion; that way, I'll get both hard and soft edges. I want "pop" in the sky as well as in the landscape. I cover the whole sky with cloud color (Yellow Ochre, Alizarin Crimson, and Cobalt Blue) and then add sky color, as in the previous demonstrations. The sky patches point the viewer toward the barn and trees. I don't overdo the sky; if the washes get heavy, I'll lose the all-important feeling of air. Remember: a landscape without air is like a body without bones!

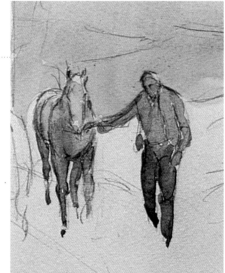

DETAIL 1. Note that I pull the sky right into the mountains. Later, I'll paint the mountain tops and let the sky color suggest mist in the valleys. Notice, also, how the same reddish color appears in the figure's jacket and pants. The color ties the figure together and prevents him from becoming a bunch of different color spots.

4 I set the buildings into the ground by avoiding a hard edge there. The barn is painted with Cadmium Red, Cobalt Blue, and a touch of Yellow Ochre. Raw Sienna is added to what will eventually be the dark sides of the building; it's a vibrant color and suggests that reflected light bounces into these out-of-light areas. The distant in-light grass is painted with Cadmium Red, Lemon Yellow, and Cobalt Blue. The color is also used behind the barn, where it suggests background trees catching the light. As the grass moves to the left (away from the light) I use a cool red (Alizarin Crimson) to gray the color. In the immediate foreground, however, rich, strong Cadmium Yellow is added to the mix. It pulls the area forward.

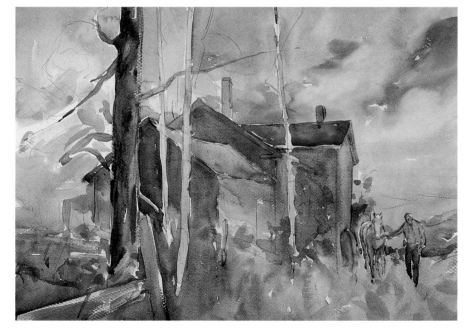

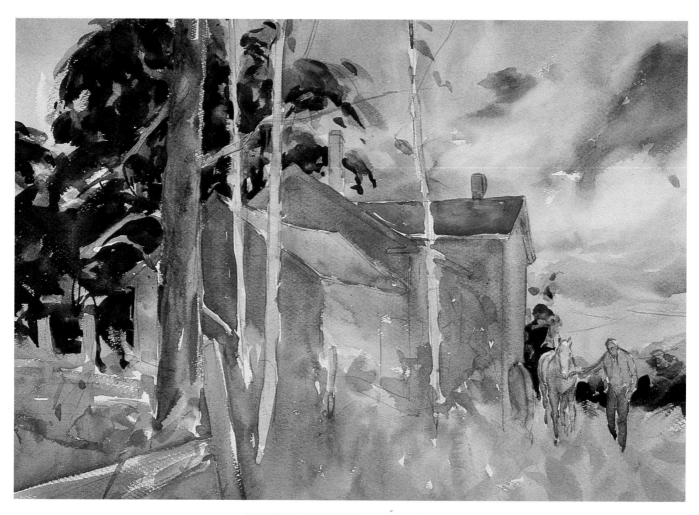

5 As in the demonstration "How White is White?" I use a light wash of Lemon Yellow and Cerulean Blue to find the general shape of the main mass of foliage. While the wash is still wet, I add more Cerulean Blue to the tops of the masses where they're touched by the sky. I also add Raw Sienna and Cobalt Blue to the wash, darkening part of it and suggesting leaves nearer to us. There are no edges within this wash; I'm just after light, values, and color change. I also give shape to the clouds by painting their dark undersides (Alizarin Crimson, Yellow Ochre, and Cobalt Blue).

DETAIL 2. The darks in this detail are a second wash, glazed over the trees after the first, lighter, wash has dried. I use Yellow Ochre and Cobalt Blue for the areas turning from the light; these two colors give me a fairly dull green. For the out-of-light areas, tucked under the leaf mass, I use Thalo Green, Ultramarine Blue, and a touch of Burnt Sienna. You can see the first wash within the mass and at its outer edges. The light color suggests distant foliage and gives added depth to the design.

6 I finish the out-of-light sides of the building, the grass, the horse, and the figure. I don't jot the grass in arbitrarily. Instead, I use the brush in a manner that suggests grass, always thinking of the layers of new and old growth. Each time I make a stroke, I concentrate on the nature of the edge: should it be hard or should it be soft? I spatter the foreground for texture and then refine these accidental marks. The light-dark contrast pulls the foreground toward you; in fact, I exaggerate these contrasts in order to convey the exciting quality of the day.

DETAIL 3. The area closest to us naturally has the most detail; you can see the knot in the tree, the texture in the bark, and the burrs on the wire. Notice the abstract quality of the darks in the grass and the distant trees. They tell about the light, and let the viewer imagine the details. The edges vary greatly. Sharp, no-light darks in the distance are softened by superimposed rough-brush marks. The tree on the right is textured with a few crisp, no-light marks; white rough-brush strokes suggest the shimmer of light on its broken surface. The side directly in light is crisp and hard. The waving grass absorbs a lot of light; as a result, it has many soft edges. This variety is typical of nature, especially on a day characterized by flickering light.

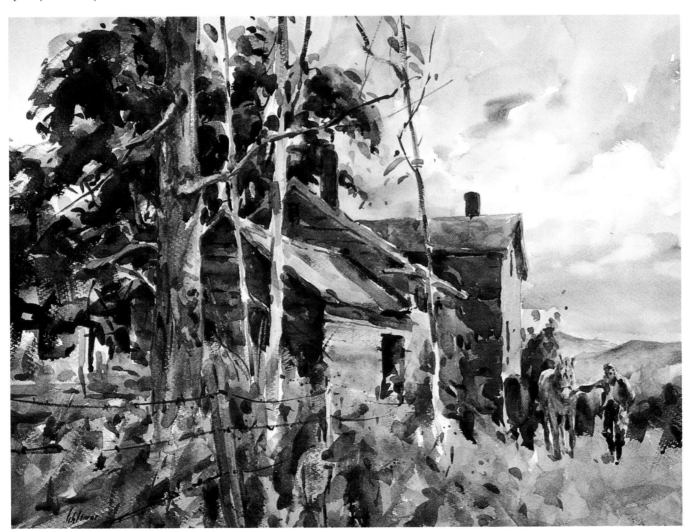

DETAIL 4. There's great variation within the sky: soft edges, hard edges, and even a few rough-brush marks. I've also left some of the water marks; in the upper left, for example, they suggest where one cloud comes in front of another. To the right, the original warm wash of the sky shows through the blue glaze. The colors are thus related to one another; they're not separate, disjointed spots.

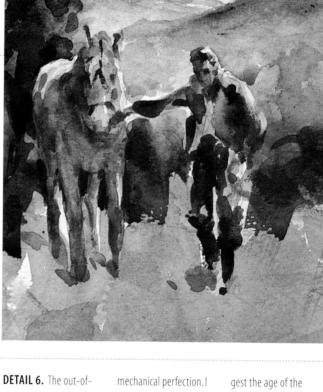

DETAIL 5. The man and horse are part of the landscape. You ran see how the broken washes of the shirt and the left-hand tree both suggest the same popping quality of light. I should note that the "simplicity" of this figure is a result of my careful preliminary drawing. Because I thought hard about him in the beginning, I can now make him look as if he were just dashed in.

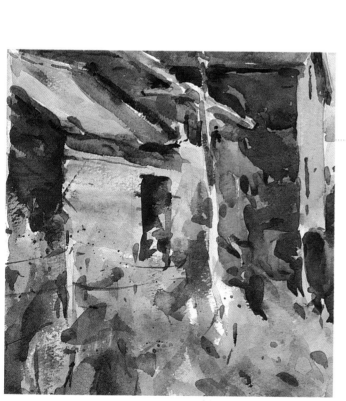

DETAIL 6. The out-of-light sides of the buildings are painted with Cobalt Blue, Ultramarine Blue, and Cadmium Red. I use a lot of water, so the warm first wash will show through the glaze and suggest areas of reflected light. I vary the wash in order to suggest the age of the farm; I don't want a flat, mechanical perfection. I rough-brush some out-of-light color over the in-light side of the barn; that suggests little shadows cast by the grain of the old wood and also varies the edge (a broken edge) of the corner where the dark and light sides of the building meet. This broken edge also helps suggest the age of the structure. The eaves are the darkest, most colorless areas (Ultramarine Blue and Alizarin Crimson). The door is first painted with Raw Sienna, a warm color that lets you get inside the building. Ultramarine Blue and Alizarin Crimson are added for the cold, dark interior.

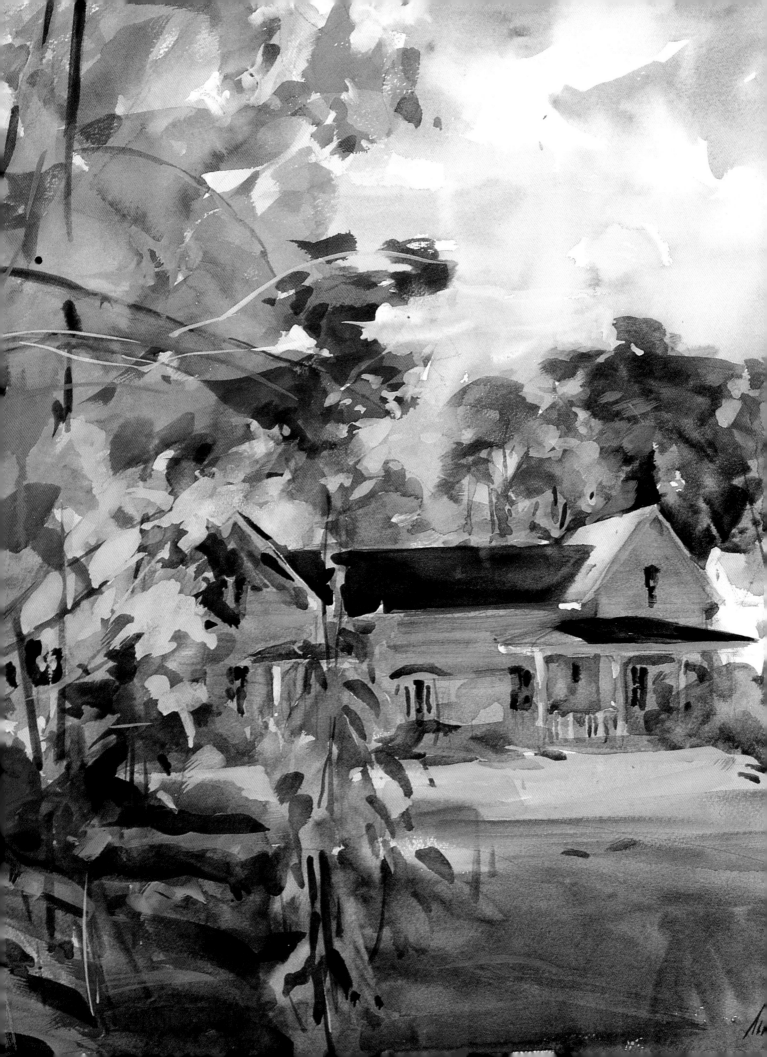

This is a quiet afternoon in Thomaston, Maine. It is made quiet by the strong horizontal-vertical dominance of the painting's structure. The light was so warm and, on this painting, backlighted. I purposely made the foreground in dark cool shadow, using the value jump along with these cools to express the intensity of the light. I did this painting on location and with light and shadow. I first go to the white house because the values are greater there, dark to almost white paper. However, I cannot stay there because the house, in shadow, although not as strongly painted, attracts me and pulls my eye towards it. I then am able to depart to the sky and return again with the intense lighting of the orange and yellow trees basked in light.

Afternoon Light

THOMASTON, MAINE.

The house in light made me stop my car and I knew I had to paint this scene: a vegetable garden gone by, boats hauled up for the season and the glorious fall colors. Everywhere there's a play of light and shadows. This painting, done completely on location, has won me many awards, even made the American Watercolor Society Exhibition, but, somehow, I feel that it was the late afternoon light on the white house that should get the honors.

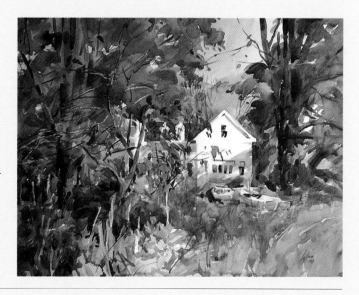

Demonstration

8

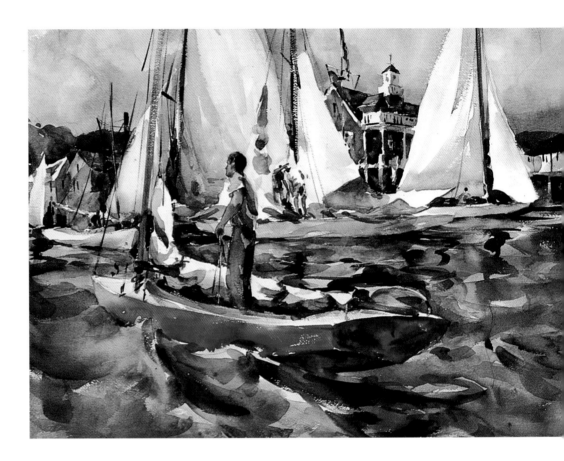

In this demonstration, we'll visit Rockport Harbor at the end of the day's races. The foreground boat leaves the action, while the distant boats are at rest, their crews exhausted.

LIGHT. Unlike the flickering light of the preceding demonstration or the soft light of the street scene in the second demonstration, afternoon light is strong and warm, a crisp light that creates equally crisp edges. In this case, the sharpness of edge not only matches the brightness of the day; it also suggests the solidity of the boats, a quality obvious to anyone who's ever heard them bump into one another. Interest is added to the picture by a special kind of light: the warm light coming through the translucent sails. Because of the large expanse of the sky and water, the picture is cool. I play up the warm color of the Sandy Bay Yacht Club and the foreground boat in order to keep the picture from going too blue.

KEY. The lights and midtones are close in value slightly above middle C. The darks are low, so they can be seen. This contrast adds extra excitement to the picture. Because the darks are low, the viewer will see the foreground figure and yacht club first. If I'd wanted the viewer to see the sails, I would have kept the midtones and darks close; then the lights would pop.

PAPER. I used a sheet of Arches 260-lb cold press, cut in half (25 x 20"). That gives me a horizontal shape, appropriate to the breadth of the harbor. The paper takes washes quickly and cleanly, a prerequisite when painting a sunny day. It can also stand a good beating, so I can correct and rework without doing too much damage to the washes.

PRELIMINARY SKETCHES. As I hope the previous demonstrations have shown, you can't paint a subject until you've gotten involved with it. It's like working in a life class; I like to talk while painting the subject, that way, I learn something about the model's personality. In this case, I spent a number of summers rowing around Rockport Harbor, studying the racing boats and painting rapidly. I had to get among the boats, for there was no way I could understand the subject from the dock.

PLANNING THE COMPOSITION. I use both kinds of movement when drawing the present design. In the distance, static horizontal and vertical lines suggest the quiet, protected area near the dock. In the foreground, a boat is only halfway out of the action in the open sea. I therefore have more activity in the water. The angle of the water parallels that of the boat, thus further emphasizing its movement. The boat is placed way to the left; you sense that it's covered a lot of territory. To counteract the boat's leftward movement, I've added the large warm mass of the yacht club. It pulls your eye back into the picture.

DETAIL 1. Things are happening in the grays. For example, I use more red in the yacht club gray so as to distinguish it from the sails. Under the porch, there's less light than on the club's cupola; the cupola is therefore lighter in value and warmer in color. Warm light (Yellow Ochre) bounces into the bottom of the sail nearest to us and shines through the jib on the far right. Notice that the side of the jib, while translucent, is also dark; it remains an out-of-light value. The grays look dark at this stage but only because they're against the pure white paper.

1&2 The drawing is held together by the contrast of horizontal, vertical, and diagonal lines. As in the preceding demonstration, I try to make the figure look relaxed and alive. He's balancing himself in the boat, shifting his weight from one foot to the other. The figure is my hardest drawing problem, and I'd never start painting until I was sure I had him right.

I claim my lights by painting the darker surroundings: the out-of-light sides of the sails and the yacht club. I use Yellow Ochre mixed with Cadmium Red, Cerulean Blue, and Cobalt Blue. The blue changes as the object goes more strongly out of the light. The strokes curve to suggest hanging and blowing sails. I do sails and reflections together; they're both part of the same big shape. As I work, I think of gray as a color, a color that needs to be related all over the picture. Notice how the grays to the right are balanced by the one upright gray mass on the far left.

3 I creep up on the vivid red boat by first doing the buildings on the left. The farther building is Lemon Yellow with Cerulean Blue; the nearer, Cadmium Orange also grayed with Cerulean Blue. I get air into the washes by messing them up with a thirsty brush. I do the in-light side of the yacht club (Raw Sienna and Burnt Sienna grayed with Cobalt Blue), adding Ultramarine Blue for the out-of-light area under the porch. The flesh of the sailors is Yellow Ochre, Alizarin Crimson, and Cobalt Blue, and looks dark against the light sails. I use Cadmium Red for the foreground boat, adding Cadmium Orange to move it toward the light and Alizarin Crimson to move it away. I break the wash where light reflects up from the dancing water.

DETAIL 2. The boat is the strongest warm note in the picture; it's the star! Here, you can see the different lights at work. The stern was painted with Cadmium Red and Alizarin Crimson. Extra Alizarin Crimson is added to darken it. Cobalt Blue reflects into it from the water. Ultramarine Blue is added to the darkest, most colorless parts of the boat (under the stern and the lip of the deck). As you can probably see, I worked wet in this area; color always sings in a wet wash. I paint the reflection of the boat with lively, dancing marks, running the hull of the boat into the water, so the two are related to one another. Reflections are usually a little darker, duller and warmer than the object being reflected.

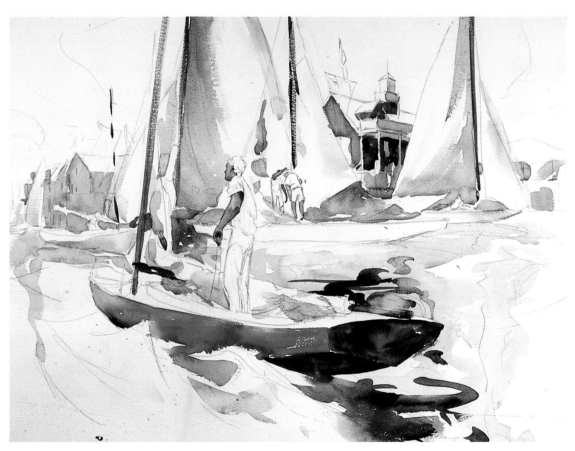

4 Now I do the sky and water, my big midtone pieces. The sky wash is graded from Yellow Ochre (near the sun) to Cadmium Red (farther from the sun). I add Cerulean Blue and Cobalt Blue as in previous demonstrations. Although I darken parts of the sky to accent the sails, the out-of-light sides of the sails are still darker than the sky (the same principle we noticed when painting a white house). The sky color reflects warmer in the water. Notice that the warm color hits not only the water but also the wet deck of the foreground boat: the bow catches some Yellow Ochre, while the stern, moving from the light, has more of the cooler Cadmium Red in the mix.

5 I use Ultramarine Blue, Alizarin Crimson, and Burnt Sienna to paint the dark, no-light area under the wharf and the stern of the foreground boat. The colors break up in the wash. Even these darks have air in them. The clothing of the distant figures is grayed by atmospheric perspective. The foreground figure wears a blue shirt and pants whose color is closely related to that of the deck. The closeness of color helps hold the shapes together.

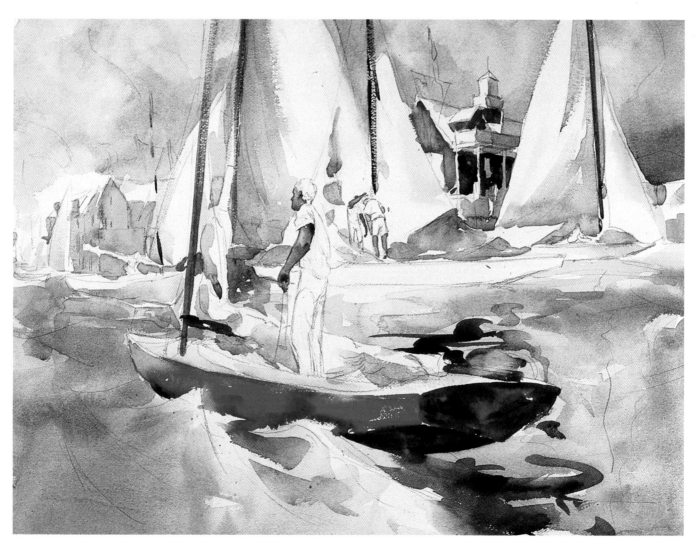

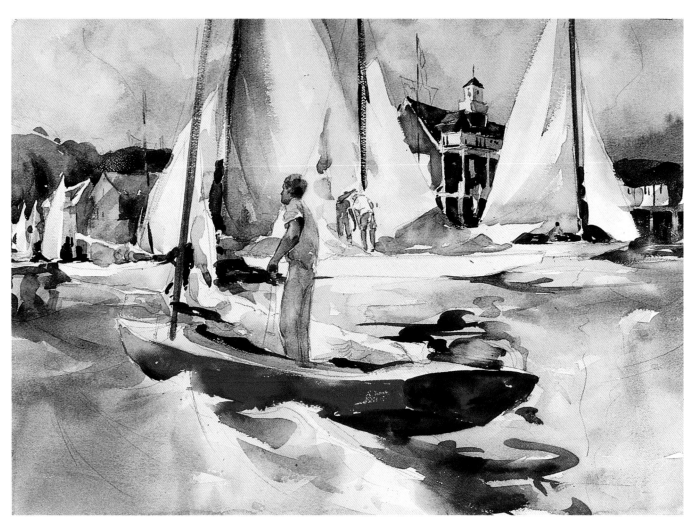

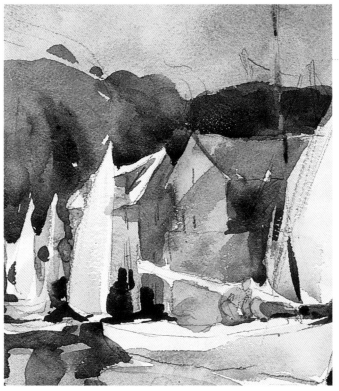

DETAIL 3. The area of background trees is first painted with Cerulean Blue and Yellow Ochre. While wet, more Cerulean Blue is added to the top of the trees (sky color), more Yellow Ochre to the sides facing the sun, and Cobalt Blue to the area turning from the light. As I've previously noted, I wouldn't use a color like Ultramarine Blue in this area; I save that for my real darks. Besides, I also happen to like Cobalt Blue, and so, I use a lot of it. Remember: we're not automatons, mixing our colors according to some formula. Likes and dislikes play a large part in how we work.

I try to keep the shapes in this area as simple as possible. Since I'm saying a lot about sails in this picture, I emphasize them by an expressive repetition of pointed sail-like shapes in the trees and the eaves of the buildings. The cast shadow on the orange house is Cobalt Blue, grayed with Yellow Ochre and Cadmium Red. I use lots of water, so the wash is transparent and full of air.

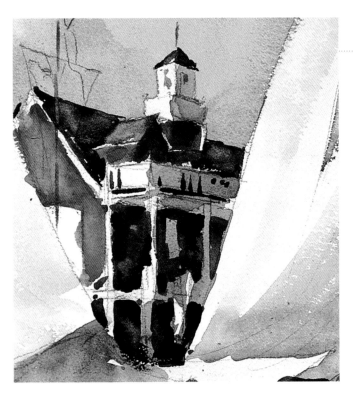

DETAIL 4. Notice the simplicity of the sails; I could paint the seams in the cloth, but that wouldn't add anything to the picture. The dark roof of the yacht club is first washed in with Cobalt Blue and Raw Sienna. I add more Raw Sienna when doing the dormer facing the light. I also use Ultramarine Blue, Alizarin Crimson, and Burnt Sienna for the no-light accents around the porch railing and under the wharf. Notice how light the trim looks, now that it's surrounded by darks. Notice, also, the broken edges around the yacht club. This is a working club, and the rough-brush edges give it character.

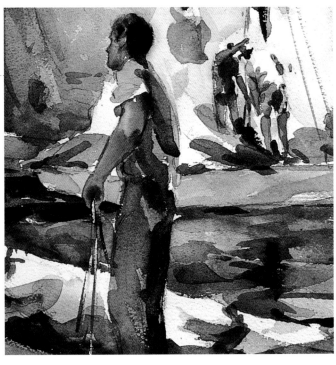

DETAIL 5. The front of the shirt is touched with Yellow Ochre while the back catches cool light (Cerulean Blue) from the sky. The pants are basically Cobalt Blue and Burnt Sienna, with Raw Sienna in the light and Cerulean Blue in out-of-light areas. Darks connect the shirt to the pants and the figure to the boat. As a result, the man belongs to his surroundings. Imagine how he'd look if I'd given him purple pants and a yellow shirt! The darks around the background figures also connect them to their boat. I keep the edges hard in order to emphasize the crispness of the light.

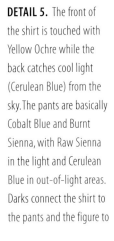

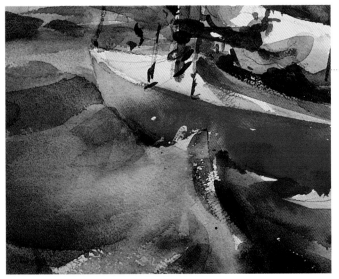

DETAIL 6. The big swell in the water is painted with Cobalt Blue, Ultramarine Blue, and Cadmium Red. Yellow Ochre is added to the in-light side, while the blues predominate on the out-of-light side. I made the trough to the far right particularly dark in order to emphasize the boat's diagonal movement into the picture. Notice how exciting the foreground strokes are. I'm working for a feeling of movement, and I can't see much activity if I spend all my time on the dock.

6 The boat in the distance presents a flat side to us. In-light, it's painted with Yellow Ochre and Alizarin Crimson; I use more Cobalt Blue as it moves from the light. Variations in the wash add to what I think of as the "pop-pop-pop" quality of the light; the excitement when light bounces back and forth among the moving forms. I use dark glazes to kill some of the light in the water; that makes the sails stand out. Some of the original wash can be seen, however; as we've seen in previous demonstrations, this gives a sparkle to the reworked area. The dark reflections emphasize the height of the masts while also framing the red boat and keeping the viewer's eye in the picture.

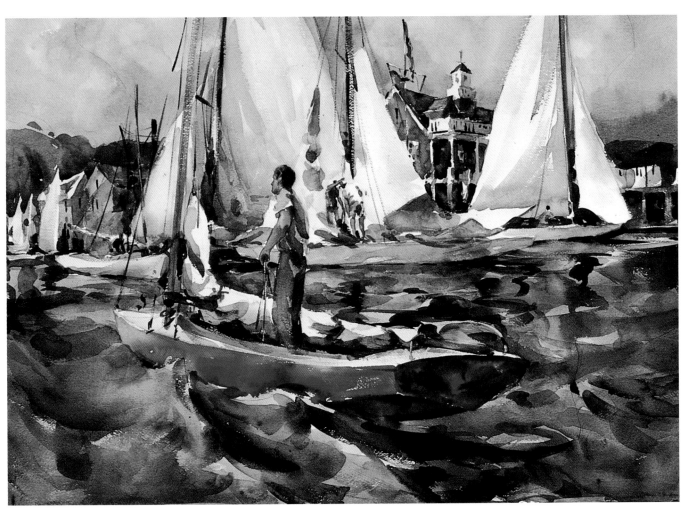

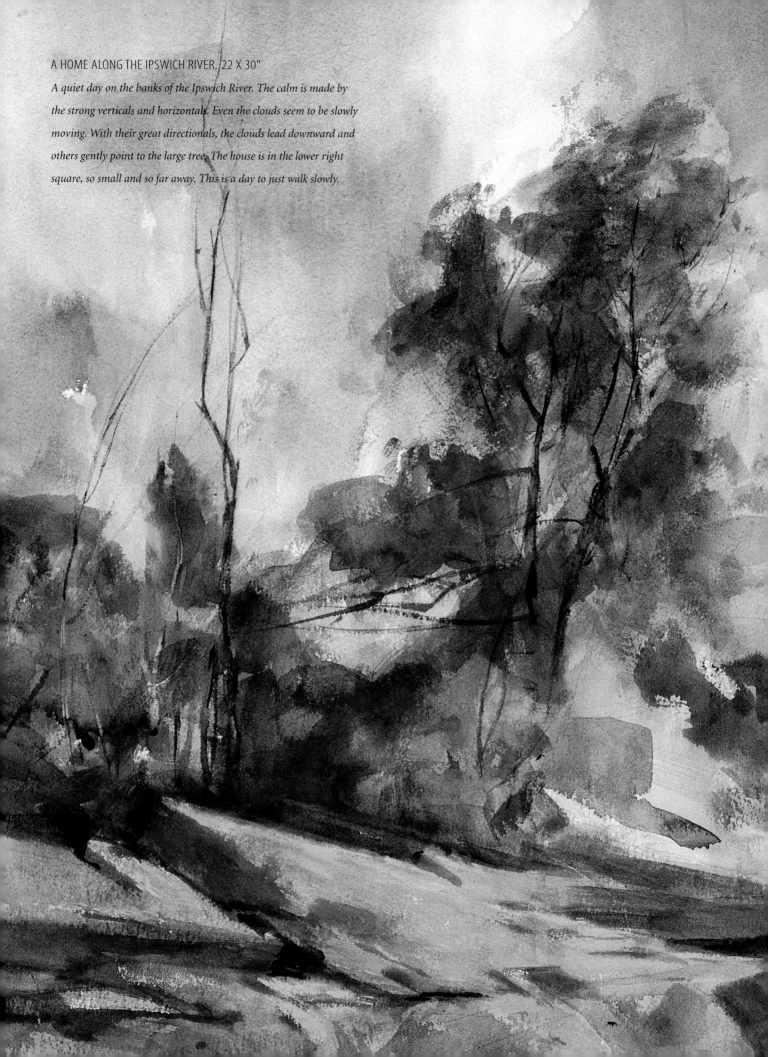

A HOME ALONG THE IPSWICH RIVER. 22 x 30"

A quiet day on the banks of the Ipswich River. The calm is made by the strong verticals and horizontals. Even the clouds seem to be slowly moving. With their great directionals, the clouds lead downward and others gently point to the large tree. The house is in the lower right square, so small and so far away. This is a day to just walk slowly.

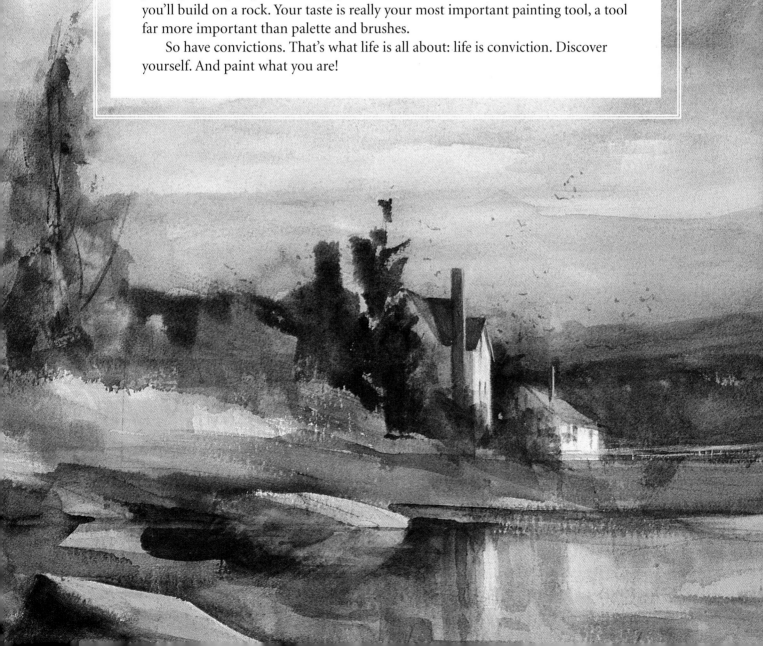

As a painter, you shouldn't learn "how to do." You should learn "how to think," then you'll be able to tackle anything. It's your job, as a student, to practice the craft of painting, the actual laying on of paint. The teacher helps you see the beauty and truth of what's around you. Use the teacher. Go to him or her to study your weaknesses. Progress comes from developing these weak spots. Give them everything you've got. The strengths will take care of themselves. Whistler, the great portrait painter, once had a woman pose for over eighty sittings. She ran off, thinking the painter mad. But in the end he got a masterpiece.

Stop and work on your own, too. Associate with good artists. And if none are handy, go to the museum. When you look at paintings, you talk to their creators. See lots of art — and keep good company.

And don't be afraid of being influenced. After all, a teacher is supposed to inspire the student. But don't let the teacher become a crutch. When you build on someone else's style, you build on sand. Try instead to understand the attitudes both of your teacher and of other painters. Why do they paint the way they do? — not how do they do it? By thus studying the thinking behind the work of other artists, you'll gradually begin to develop your own taste. Build on that taste and knowledge; you'll build on a rock. Your taste is really your most important painting tool, a tool far more important than palette and brushes.

So have convictions. That's what life is all about: life is conviction. Discover yourself. And paint what you are!

List of Paintings

* Denotes private collection

Index